Hummingbirds

Marvels of the Bird World

Written and Photographed by
STAN TEKIELA

Adventure Publications
Cambridge, Minnesota

Cover photos by Stan Tekiela
All photos by Stan Tekiela except pp. 2–5 by **mr.Timmi/Shutterstock.com**; and p. 44 by **yhelfman/Shutterstock.com**
Edited by Sandy Livoti and Brett Ortler
Cover and book design by Jonathan Norberg
Range maps produced by Anthony Hertzel and Jonathan Norberg

10 9 8 7 6 5 4 3 2 1
Hummingbirds: Marvels of the Bird World
First Edition 2010 (entitled *Amazing Hummingbirds*)
Second Edition 2022
Copyright © 2010 and 2022 by Stan Tekiela
Published by Adventure Publications
An imprint of AdventureKEEN
310 Garfield Street South
Cambridge, Minnesota 55008
(800) 678-7006
www.adventurepublications.net
Printed in China
ISBN 978-1-64755-246-6 (pbk.); 978-1-64755-247-3 (ebook)

Dedication

Dedicated to my father, a man of strength who loved little tiny birds

Contents

Amazing hummingbirds

As far back as I can remember, I have loved all birds. However, if I had to come up with a list of my favorites—the fantastic birds that have found their way deep into my heart—hummingbirds would occupy a prominent spot at the top. Their tiny size, giant personalities, amazing colors and mind-boggling ability of flight are just a few characteristics that draw me to hummers as a naturalist and photographer. After more than 30 years of photographing and studying these miniature marvels, here is their incredible story.

Enjoy the Hummingbirds!

Stan Tekiela

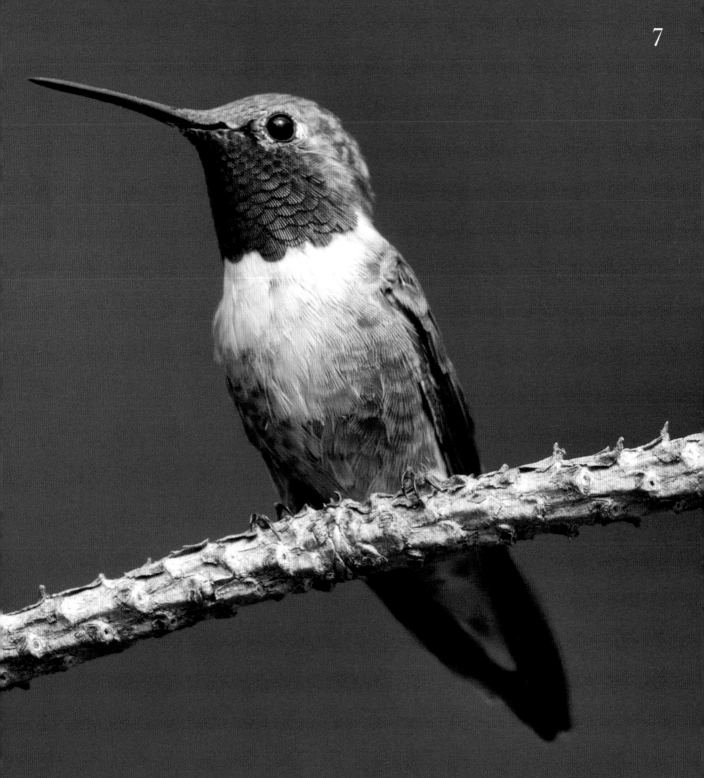

Broad-tailed Hummingbird

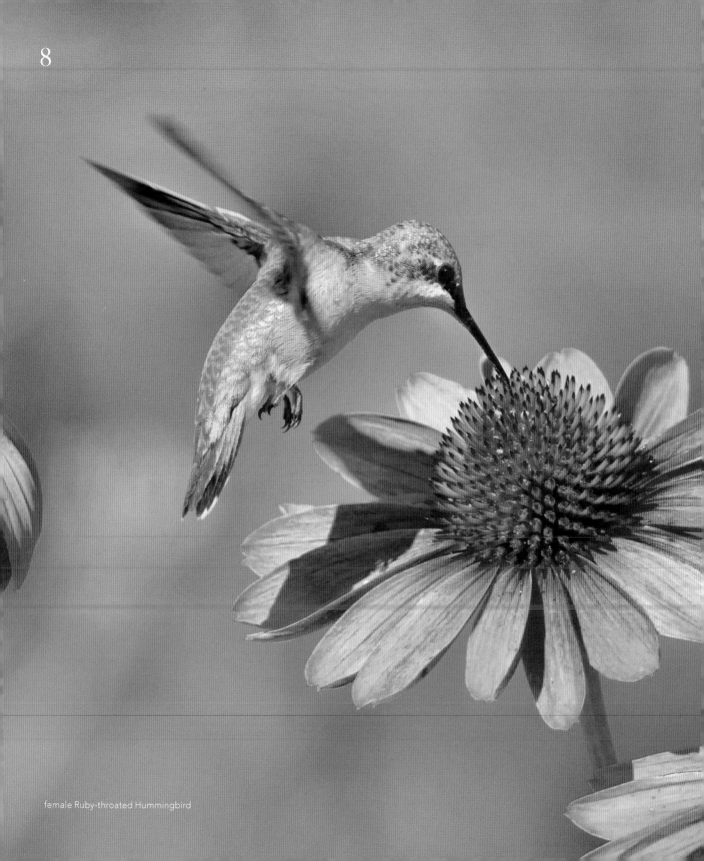

female Ruby-throated Hummingbird

The hummingbird family

Biologists who study birds, called ornithologists, group similar birds into families. The hummingbird family, known as Trochilidae, includes more than 350 species. Compared with the other bird families, this one is huge! It is the second largest in size after the flycatcher family, which has around 400 species.

Hummingbirds are New World birds found only in North, Central and South America. These tiny flying jewels were unknown to European science until settlement, and the wide variety of hummers must have mystified the early ornithologists. Even today, it's not clear why there are so many different species of hummingbirds.

The Trochilidae family is divided into six subfamilies. Hermit hummingbirds belong to the Phaethornithinae subfamily. They live in the tropical lowlands of southern Mexico and range down into South America. Hermit hummers have large down-curved bills and tend to be relatively drab in color.

Tropical hummingbirds are members of the Trochilinae subfamily. The majority of all hummingbirds, including all species in the United States and Canada, belong to this subfamily. With their wide variety of sizes and colors, long or short bills and conspicuous, colorful males, they appear more like what we consider to be typical hummingbirds.

None so fair

North American hummingbirds are some of the most easily recognized birds and are characterized by many unique features. These petite treasures are well known for their specialized, brightly colored, sparkly feathers, which refract sunlight almost like a prism. Unlike most other birds, hummers enjoy a distinctive diet of nectar liberally seasoned with minute insects. For sipping their sweet drinks, they sport a long, narrow bill that slips easily into flowers and nectar feeders.

They are very fast, agile flyers and the only birds that truly hover in flight. Many birds can remain stationary, or hover, for a few wing beats if they have a good headwind, but they cannot sustain their hover like a hummingbird. Incredibly, hummers can also fly backward! They are the only birds that can also fly straight up and down, side to side and even flip around in an aerial somersault. The key to all of this fantastic flight is their size and weight.

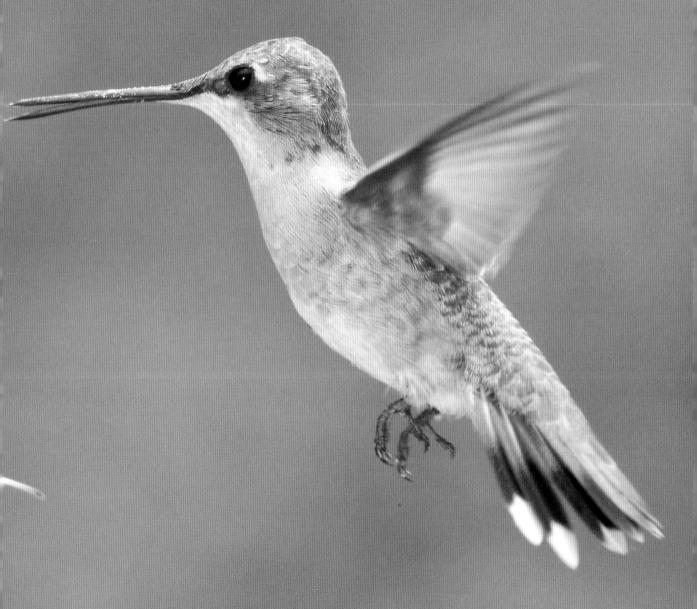

female Black-chinned Hummingbird

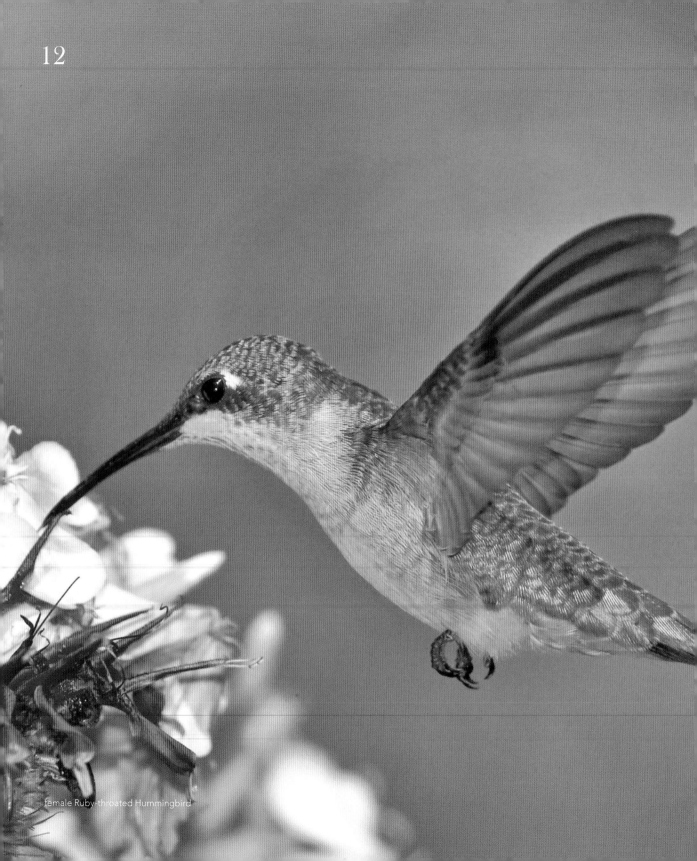

female Ruby-throated Hummingbird

A good name

Some birds have misleading names. Red-bellied Woodpeckers, for example, don't have a noticeable red belly. They have just a slight red blush that is easily missed unless you are nearby and viewing the bird from underneath.

Few birds are as well named as the hummingbird. Just listen for the humming sound you'll hear as they fly by and you will understand the reason for the distinctive name. The sound, however, is not made with the vocal chords. It's actually created by the wings, which flap incredibly fast. Hummer wings move so much air so quickly that audible reverberation is produced.

A Ruby-throated Hummingbird flaps its wings 70–80 times per second during regular flight. The extraordinary speed of the wing beats makes it difficult to photograph a hummer in flight, freezing it in time. This image shows flight movement captured in less than a hundred-thousandth of a second. During specialized courtship flights, a Ruby-throat will flap up to a tremendous 200 times per second! Try doing anything 200 times in less than 60 seconds and you'll agree that these birds are beyond amazing.

Origins of the species

The scientific view of the origin of hummingbirds is murky at best. Because only a few fossils are preserved of these very slight birds, scientists have offered theories. Some think that the ancestors of hummers were insect-eating (insectivorous) tropical birds. As the ancient birds gleaned insects from plant leaves and flowers, some individuals would have discovered nectar deep within the blossoms. Over thousands of years and countless generations, the insect-eating birds came to feed regularly on quick-energy nectar and continued to eat the insects for protein.

Over the same amount of time, the plants would have evolved flowers with long tubular shapes specifically to favor the bills of hummingbirds and exclude other birds with short bills. As a result, cross-pollination occurred when the hummers sampled nectar and unwittingly transported pollen from one flower to another. Over the ensuing thousands of years, hummingbird bills became longer and narrower, affording the birds better access to flower nectar. These events bring us into the present, when hummingbirds with long, narrow bills not only feed on nectar from long tubular flowers, but also eat insects.

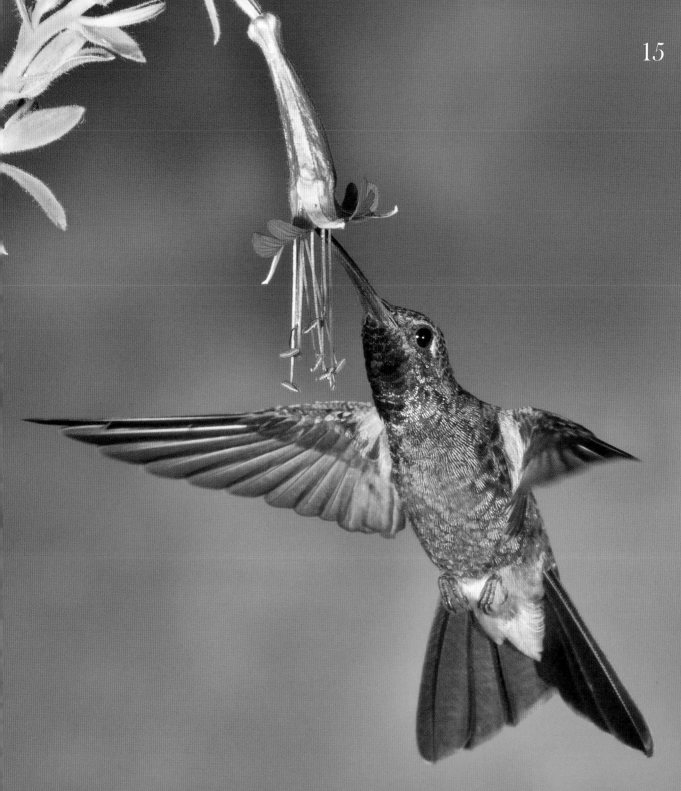

Broad-billed Hummingbird

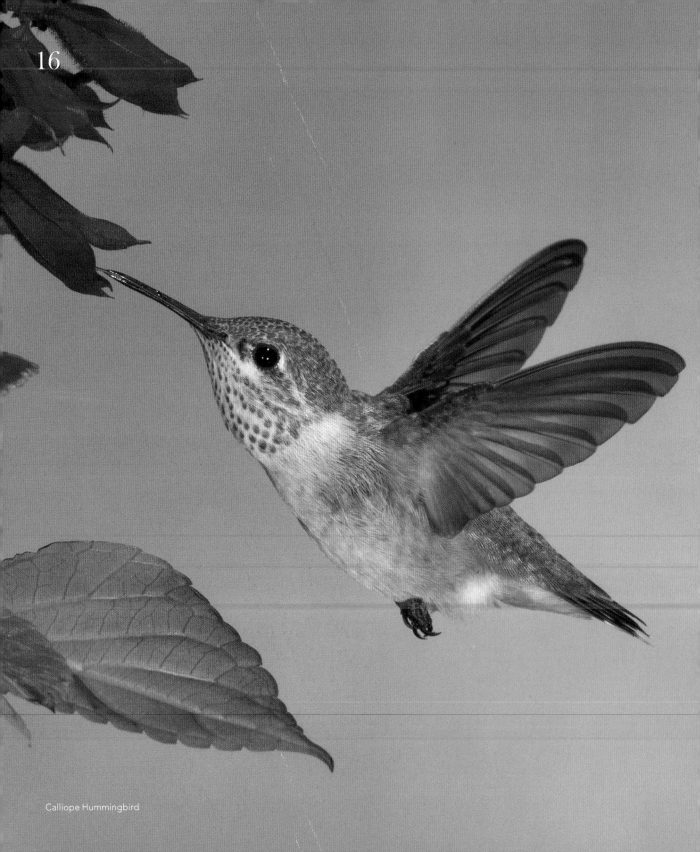

Calliope Hummingbird

The world's smallest bird

All hummer species are extremely small. In fact, the smallest bird in the world is a hummingbird. The mini Bee Hummingbird, which occurs in Cuba, is only 2 inches long and weighs 1.8 grams—about 6/100 ounce. The smallest hummer in the United States is the Calliope Hummingbird. It weighs just 2.5 grams, which is still miniscule at under 1/10 ounce. The Calliope is noticeably smaller than the other hummingbirds and also has a very short bill. The weight range of a Ruby-throated Hummingbird is slightly more at 2.7–3 grams, making it about the weight of a U.S. penny!

On average, a hummingbird weighs a full gram less than a single Bald Eagle primary flight feather, which weighs about 4 grams. In most species, female hummers are just a bit larger than the males.

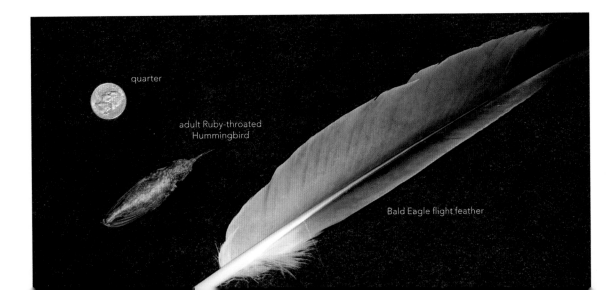

quarter

adult Ruby-throated
Hummingbird

Bald Eagle flight feather

Hummingbirds have a highly modified body that reduces their weight to almost nothing. For example, they have teeny legs and feet that add little weight and function mainly as a grip for holding onto branches and other perches instead of walking. Wing bones are also reduced and don't bend at the wrist like they do in other birds. Hummers have a rigid wing instead, which is long, narrow and pointed.

A flat sternum, or long bone in the chest (like the breastbone in people and other mammals), is too heavy for avian flight. Instead, birds have a thin, lightweight chest bone called a keel. The keel has a large surface area where powerful flight muscles attach. The lack of teeth cuts more weight, and a slim, lightweight bill and hollow bones help to trim the overall weight.

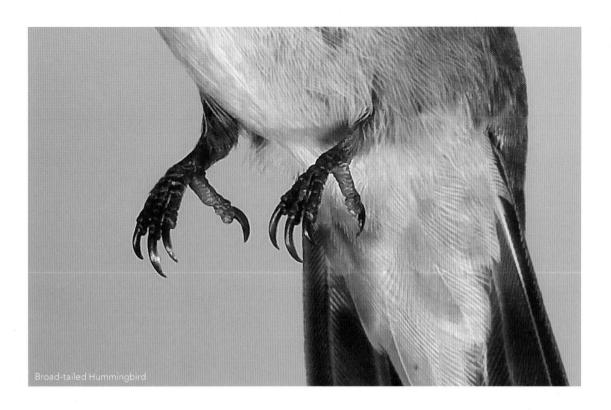

Broad-tailed Hummingbird

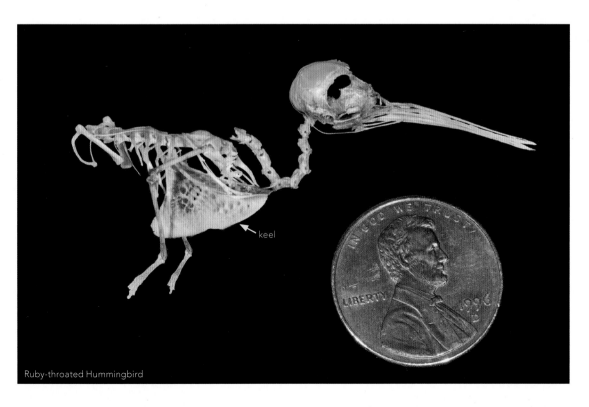

keel

Ruby-throated Hummingbird

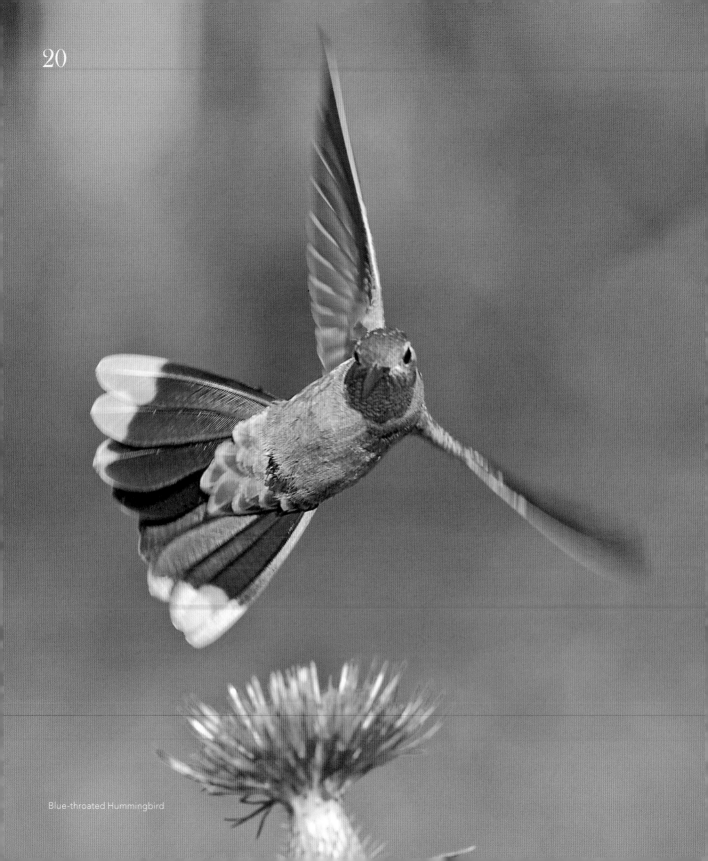

Blue-throated Hummingbird

Life span

In most birds, the larger the bird, the longer the life span. Reversing this—the smaller the bird, the shorter the life span—you'd be correct to assume that hummingbirds don't live a long time. A Broad-tailed Hummingbird remains one of the oldest recorded hummers. It had a 12-year life span, which is an extremely long life for such a small bird. The longest-living Ruby-throated Hummingbird is on record at just over 9 years, but this is also an exception. Most hummers live a short 4–6 years. Others live only 2–3 years.

Hummingbirds not only fly fast, they also live fast. Only about 50 percent of all hummers that hatch survive their first year and live to adulthood. Hummers have a maximum of two chicks per year. Thus, adults need to live at least two breeding seasons to replace themselves and three breeding seasons to add to the population.

What is most remarkable is that such teensy birds are able to survive at all. Many things can cause the demise of these pretty little jewels. Early and late frosts and freezes take a toll on all hummer species. Their high-energy requirements don't allow for long periods of cold and going without food. Hail storms also kill a surprising number of hummingbirds. In my own experience, after a strong, hail-producing afternoon storm, five hummers disappeared from the population of six that had been visiting my feeders. That population never recovered, even many years later. In addition, migration is exceptionally rigorous for hummingbirds. Obstacles, predators, bad weather and more contribute to their mortality during this time.

Staying alive

Hummingbirds have a surprising variety of predators. They range from the usual suspects, such as hawks, to the particularly unusual, such as the praying mantis. The mantis, a relatively large, well-camouflaged insect, often hangs from a twig or stem of a flower close to where hummers visit. When an unsuspecting hummer flies within reach, the mantis snatches the bird from midair. Mantids are not the only insect predator. Hummers are reported to have been caught in spider webs. While the dainty bird struggles to break free of the web, the resident spider subdues its prey with a bite.

Another unusual predator of hummingbirds is the bullfrog. This huge aquatic frog sits motionless and camouflaged at pond edges, where hummers come to drink and bathe. An unwary bird busy at the water can quickly disappear down the throat of this amphibian with a flick of its sticky tongue.

Sharp-shinned Hawks and larger birds that feed exclusively on other bird species will also catch and eat hummingbirds on occasion. Another large, atypical predator is the very smart Greater Roadrunner, which has been spotted below hummingbird feeders, waiting for a victim. When the opportunity arises, it jumps straight up, snatches a hummer from midair and runs off to eat in private. In the American Southwest, large lizards are also known to take hummers.

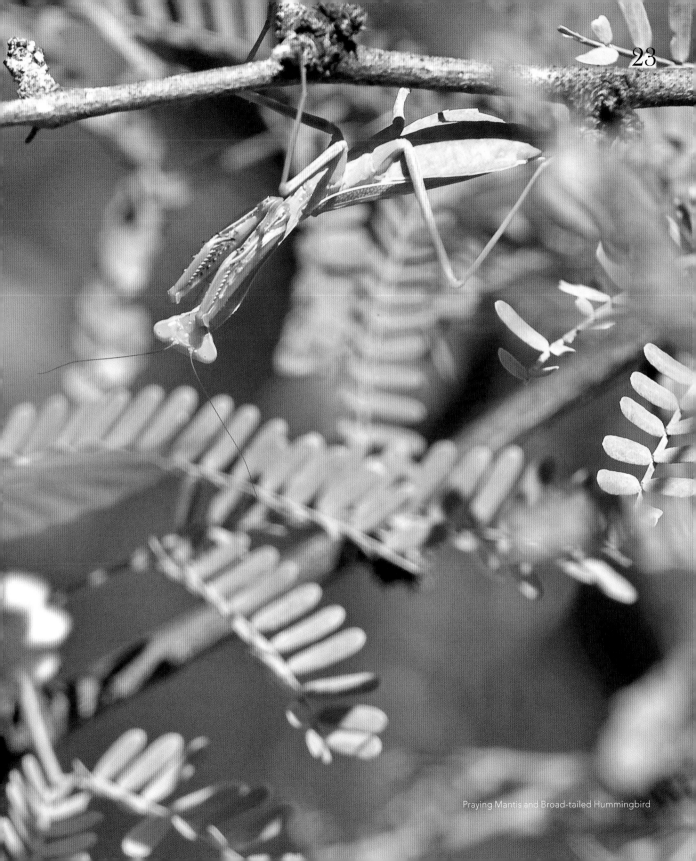

Praying Mantis and Broad-tailed Hummingbird

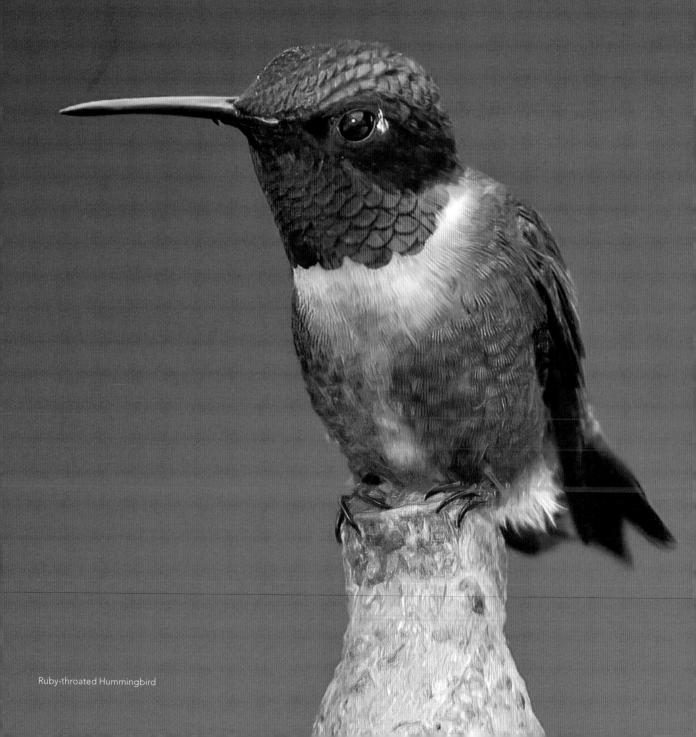

Ruby-throated Hummingbird

Hummers from coast to coast

Hummers range from Alaska in the northwest to Labrador in the northeast to Tierra del Fuego in the tip of South America. In the United States and Canada, 16 hummingbird species can be found with regularity. Another 2–4 species show up every now and then. These represent only about 6 percent of the total hummingbird species in the world.

Even with such a small percentage of the total species, we have a modest variety of hummers. In the eastern half of the country and most of southern Canada, only one species is seen—the beautiful Ruby-throated Humming-bird. The Ruby-throat has the largest range of any U.S. hummer, extending from Texas to northern Florida, northward up the East Coast to Labrador, across southern Canada to the middle of Canada, and southward to Texas. This species winters in southern Mexico, which requires an astounding non-stop flight of 500–600 miles from the U.S. Gulf Coast to reach the wintering destination across the Gulf to Mexico. Of course, the birds have to repeat this long trip in reverse come spring.

The other 15 hummingbird species occur in the western halves of the United States and Canada. Most have limited ranges. Allen's Hummingbirds occur along the Pacific Coast, stretching from Oregon to southern California, while Buff-bellied Hummingbirds are found in southeastern Texas and Mexico only. Tiny Calliope Hummingbirds live in western mountainous states such as Idaho, Washington and Colorado, and southwestern Canada. Large Blue-throated Hummingbirds, as well as Lucifer, Rivoli's and Violet-crowned Hummingbirds, are seen in several mountainous areas of southeastern Arizona and parts of Texas. Broad-billed, Berylline and White-eared Hummingbirds also share that same region, but are much less common. To see the widest variety of hummers in the United States, southeastern Arizona is the best place to be. Most of the species already live there and during spring and fall migration, you will see even more of these exquisite birds.

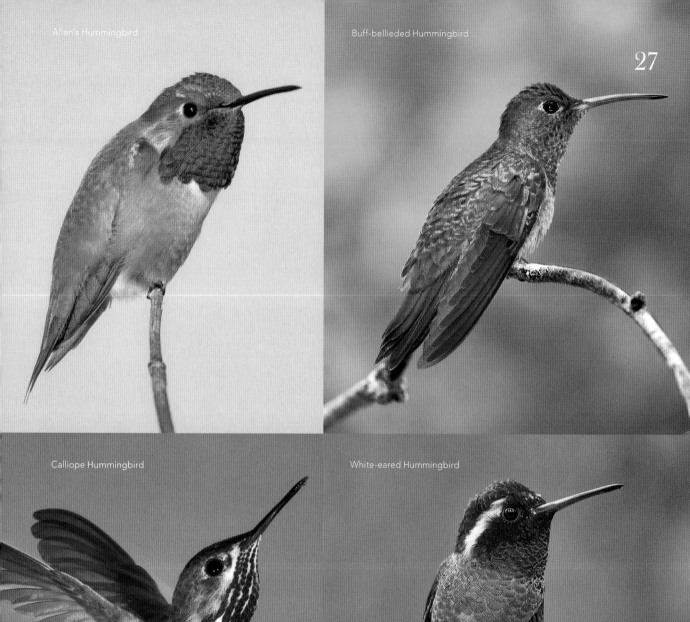

Allen's Hummingbird

Buff-bellieded Hummingbird

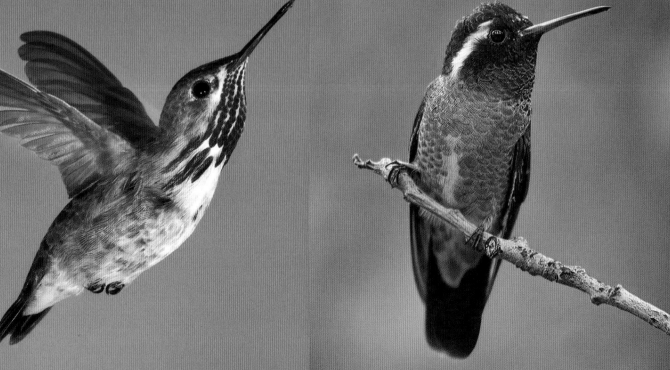

Calliope Hummingbird

White-eared Hummingbird

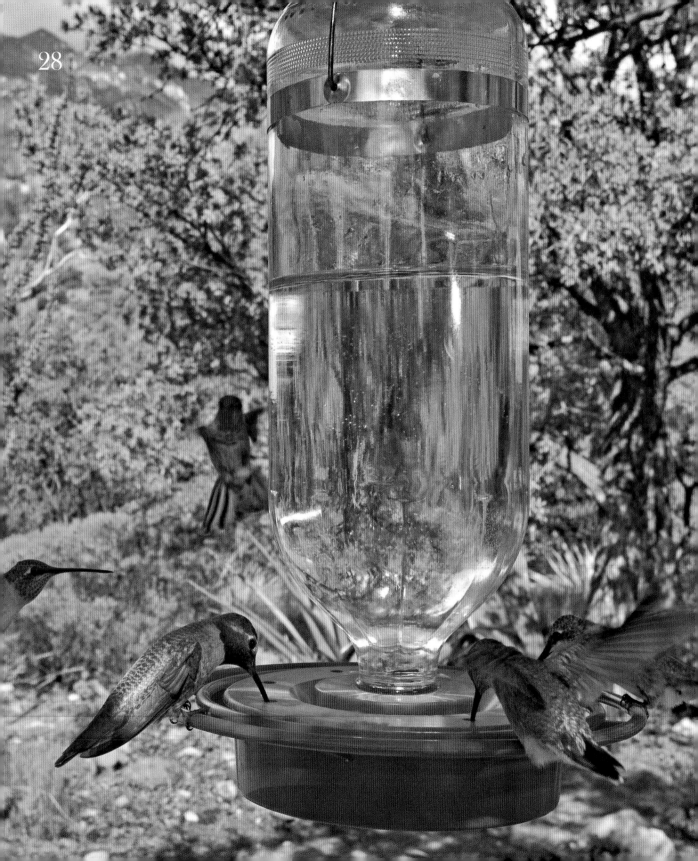

Habitats

Hummingbirds occupy a wide variety of habitats. They can be seen just about anywhere across the country, from the Atlantic seaboard to the Gulf Coast, along the coastline of the Pacific and everywhere in between. Hummingbirds thrive in the thick deciduous forests in the east to the boreal forests of Canada, across high Rocky Mountain slopes into the lowest deserts. Some species, such as the Black-chinned Hummingbird, live high up, where cold weather and snow showers are not uncommon, even in summer. Others, such as the Broad-billed Hummingbird, prefer the dry desert.

Attributes of good hummingbird habitat are nectar-producing flowers and a supply of miniscule insects. Environments that have a wide diversity of plants and even just a small amount of water without insecticides or pesticides will provide a good home for hummers. Consider these key features to attract hummingbirds to your own backyard.

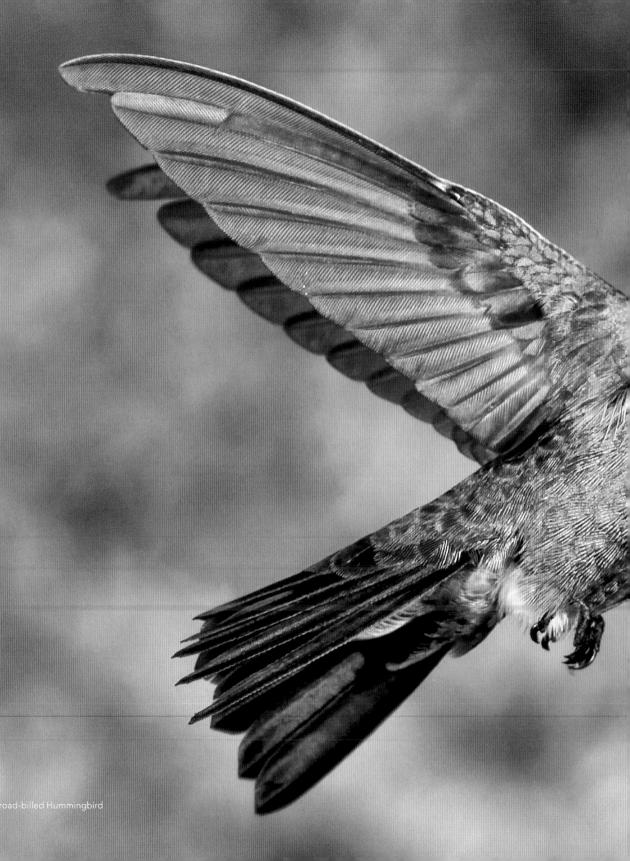

male Broad-billed Hummingbird

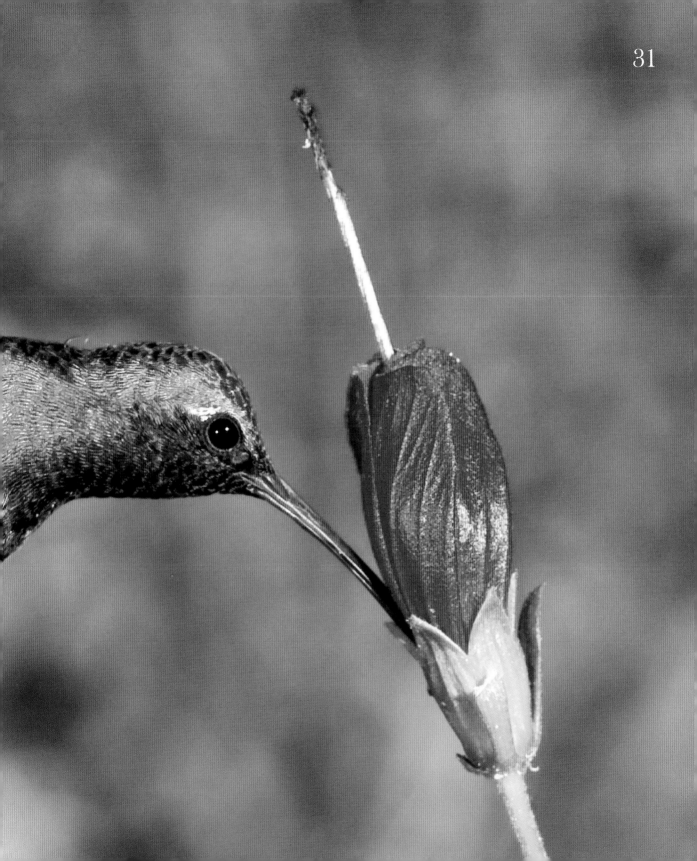

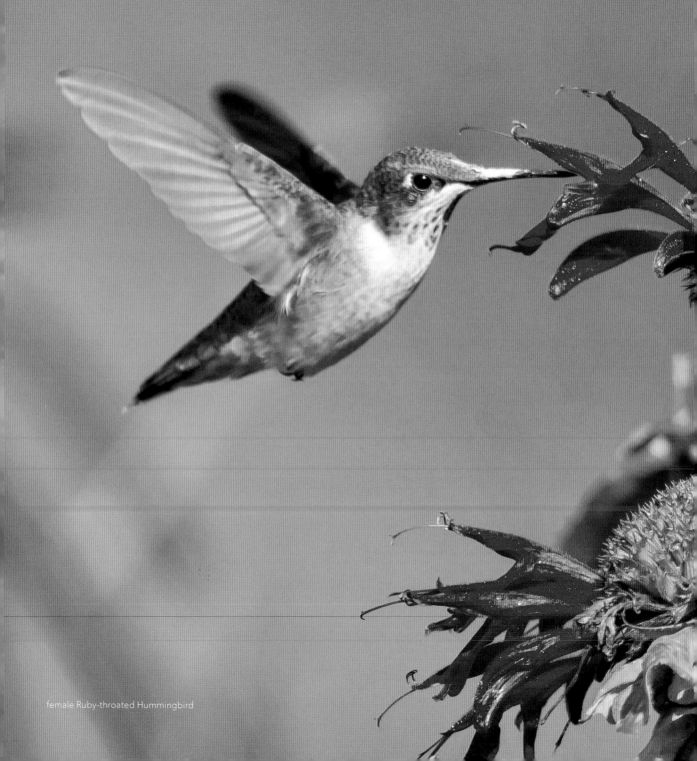

female Ruby-throated Hummingbird

Regional variations

For many species of birds, regional variations are apparent in the size of the bill, the plumage color of the male or other features. In hummingbirds, regional variation is uncommon. For example, Ruby-throated Humming-birds look the same in Mississippi as they do in Michigan. The same is true for all other hummer species in the United States.

Regional differences are apparent only in the kinds of flowers the birds visit or by the number of visits they make to nectar feeders. For example, in regions where wildflowers are plentiful, hummers won't visit feeders as much as they will in regions that lack wildflowers. In all regions, however, the preference is for flowers over feeders.

Differences of the sexes

There isn't a better example of sexual dimorphism (differences between the sexes) than that found in hummingbirds. Male and female hummers share similar colors on their heads, wings and bellies, but the male's colors are brighter and more intense. All male hummingbirds in the United States and Canada also have a specialized reflective throat patch, called a gorget (pronounced "gor-JET"), on or near the throat. In some species, the males also have reflective feathers on top of their heads. The reflective feathers from these areas glisten when viewed from the front in full light.

gorget

male Ruby-throated Hummingbird

female Ruby-throated Hummingbird

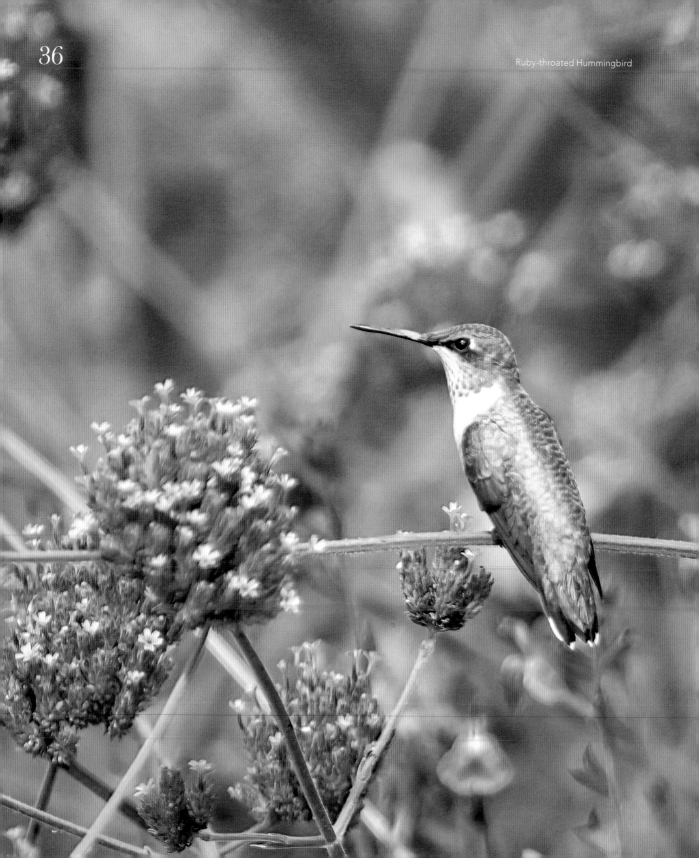

Feather lights

Hummingbirds have many specialized feathers that cover over half of their body. These feathers reflect green light, making the bird appear green. When the sun is shining, hummers light up like a neon sign. In low-light conditions, such as early or late in the day, hummingbirds look gray. The color change from green to gray also occurs on rainy or very cloudy days.

Feathers are composed of tiny barbules, or thin strands of feather. Within each barbule are cells with air spaces that act like prisms. These break up sunlight into the component bands of light—red, orange, yellow, green, blue, indigo and violet. At the base of each cell is a layer that absorbs most wavelengths of light and reflects the remaining light back to our eyes. In the throat patch (gorget) of male Ruby-throated Hummingbirds, the colors reflected are red, orange, and yellow. These create the gorget's ruby color. The remaining green, blue, indigo and violet components of light are absorbed.

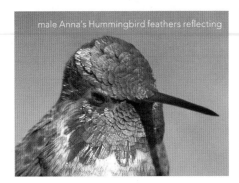

male Anna's Hummingbird feathers reflecting

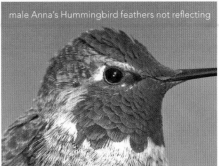

male Anna's Hummingbird feathers not reflecting

Reflective feathers

Both male and female hummers usually have some green reflective feathers at the back of their heads, on their backs and over the upper surface of their wings. The amount of green you'll see is generally dependent on the amount of sunlight and the angle at which you are viewing the bird. A hummingbird flying past you at dusk frequently appears gray because daylight is diminished. View the same bird at midday with its back toward you, and you'll see a glinting, iridescent green hummer. Male hummers have especially shiny, metallic-looking feathers. Their feathers are faceted in a flat plane, which reflects the maximum amount of light.

The distribution of reflective gorget feathers in males differs among species. Blue-throated Hummingbird males, for example, have just a small reflective patch on the throat. Male Ruby-throated Hummingbirds have a medium throat patch that shines brightly when reflecting and turns black when not reflecting. Anna's Hummingbird males have both a large gorget and reflective head feathers. A very slight change in position will turn the sparkling feather reflection on and off.

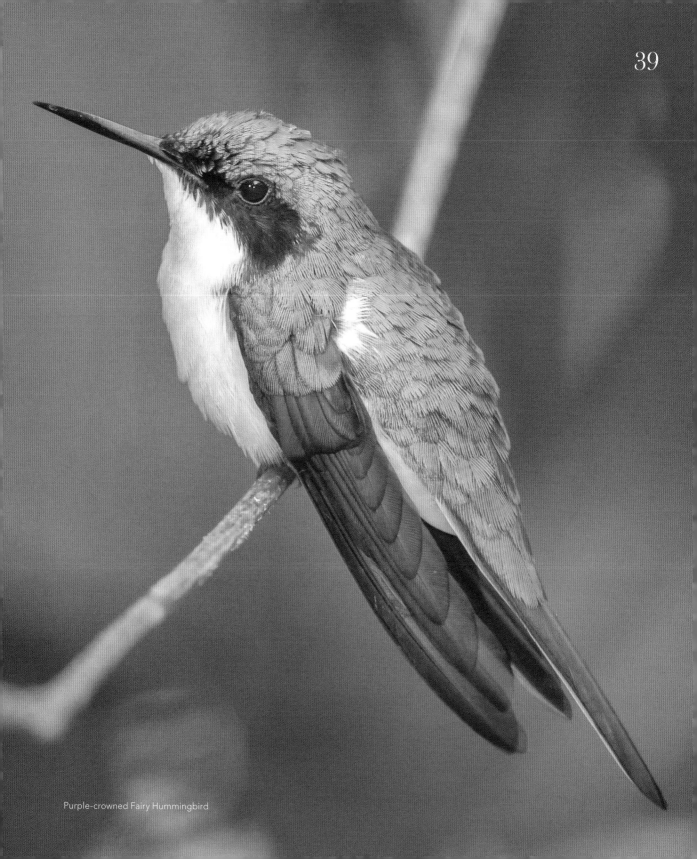

Purple-crowned Fairy Hummingbird

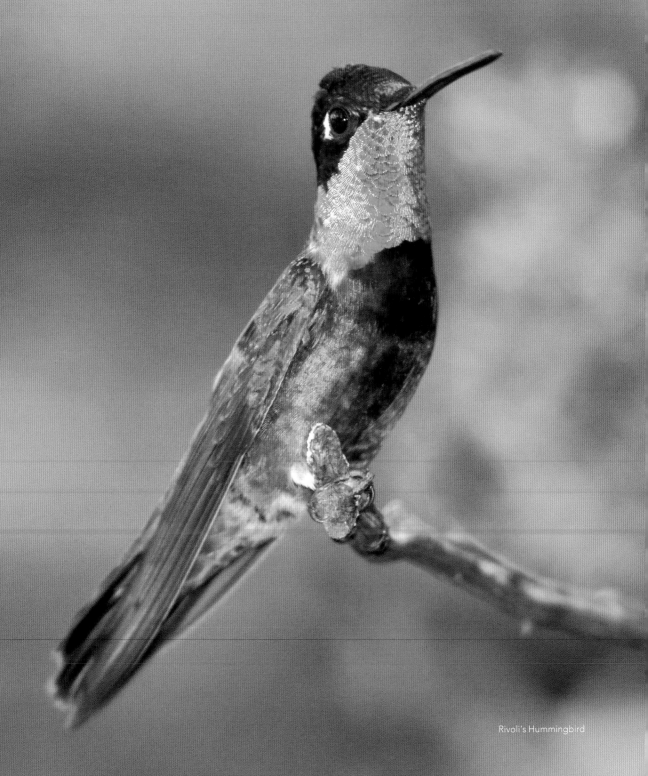

Rivoli's Hummingbird

The male Ruby-throat uses his gorget to full reflective advantage when trying to impress a mate. He will perform a flight display directly in front of the female to dazzle her with his beauty. Each time he passes, he turns his body and aligns his gorget to be perpendicular to her for maximum light reflection. The glimmering sheen from his gorget shows her that he is a healthy male.

Rivoli's Hummingbird males are different from many other hummers because they are covered with reflective feathers. With their velvety black bodies, bright green throats and glossy purple crowns, they have arguably the most striking coloration of the hummingbirds.

Adding color

Feather color occurs in different ways. Pigments in feathers produce black, gray, brown, red, yellow and orange colors. Northern Cardinals are red because of pigments. Feathers of other birds reflect color through a structural process. The specialized cells in feathers that split sunlight apart into a color spectrum also absorb most wavelengths of light and reflect the remaining colors back to our eyes. These colors tend to be green and blue. Eastern Bluebirds and Blue Jays appear blue due to the process of light absorption and refraction. Feathers that lack pigment or the cell structure for the mechanical process will be white.

Hummingbirds have a combination of all three processes. The wings of most hummers are gray, brown or black from pigments. Chests and bellies are normally white. Their backs and the upper surface of their wings are green from light reflection. The lustrous colored crowns and throat patches of the males are also classic examples of light trickery.

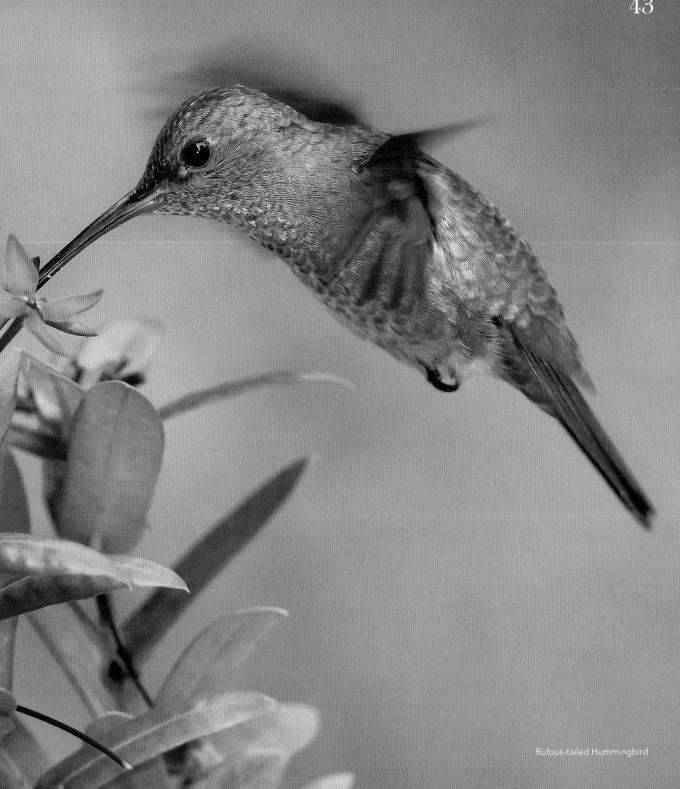

Rufous-tailed Hummingbird

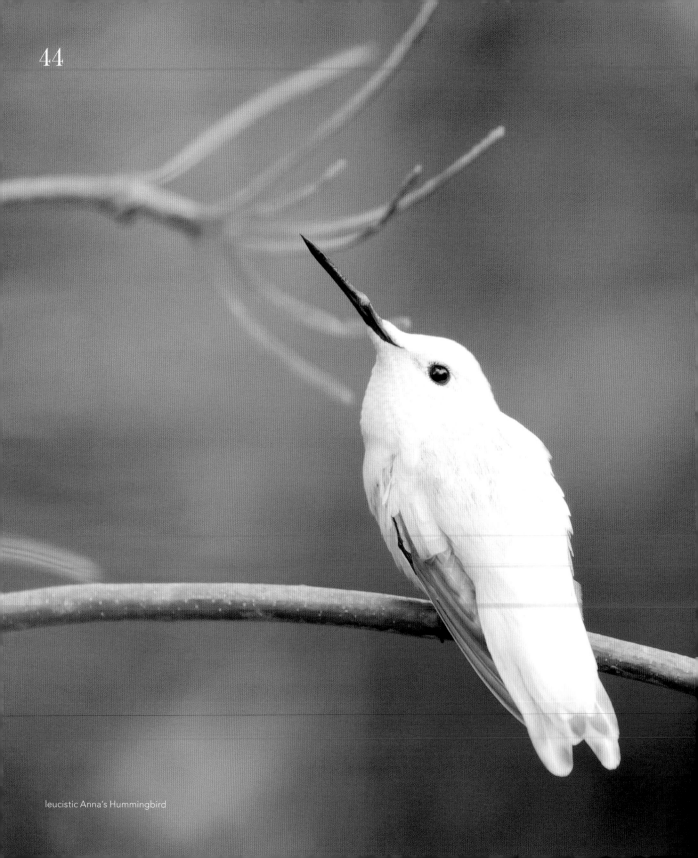

leucistic Anna's Hummingbird

White hummingbirds

Occasionally a hummingbird that is partially white or all white will show up at your feeder. Gone are the shimmering green body feathers and brilliant gorget feathers of the male. White hummingbirds lack any pigment and the specialized cells in their feathers that make other hummers green. This condition, called leucism, sometimes produces partly white plumage and other times results in just a few white feathers or an all-white bird. Leucism is different from albinism. Leucistic birds have dark eyes. Albinism is a total lack of specialized cells and pigments, including those in the eyes. Albino birds will always have pink eyes and all-white feathers.

Feather finery

Hummingbirds don't have different breeding and nonbreeding plumages. Unlike the seasonal bright and dull plumages of the American Goldfinch and some other songbirds, the magnificent feather finery of the hummingbird appears the same year-round.

The condition of feathers makes the difference between life and death in birds. Each feather needs individual attention to ensure it's clean and in top condition—which is why hummers spend much of their day perched on a branch, preening. Using the bill to grasp one feather at a time, a hummer will draw its bill down the feather from base to tip. This action repairs, smoothes and adjusts the feather and also removes dirt. Ruffled feathers that become separated during daily activities are zipped back together. Hummingbirds also fluff their feathers as needed to shake loose any bits of dirt, debris or feather particles.

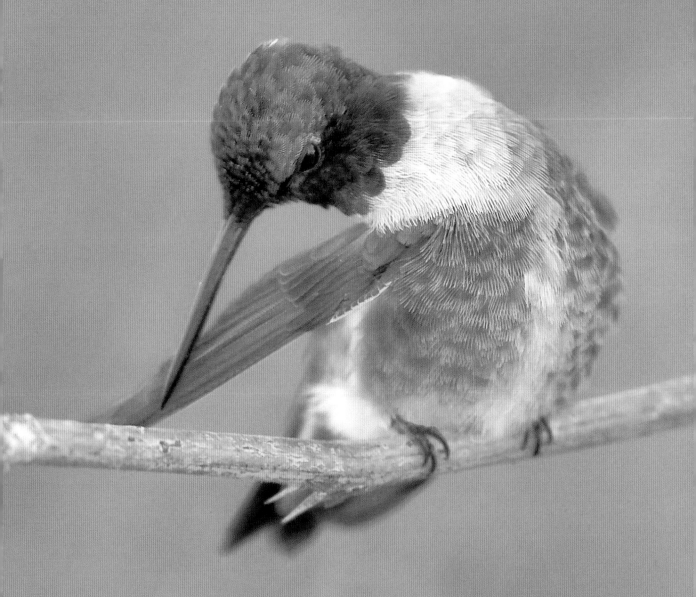

Black-chinned Hummingbird

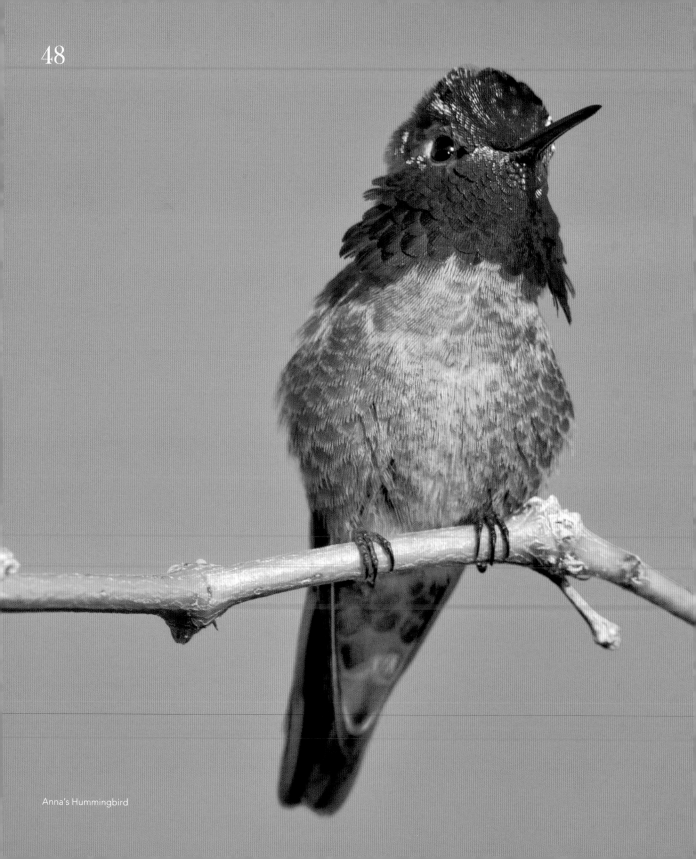

Anna's Hummingbird

Molting

Feathers are strong and lightweight, but not extremely durable. In all birds, old feathers are gradually replaced by new ones in a process called molting. Feathers are dropped and grown again in a neat and orderly way, like a wave across the body. During this period, the body feathers may look a bit disheveled, but nothing more. Only occasionally will an observer notice the loss of some feathers while a hummer is perched at a feeder. A hummingbird molts its body feathers once a year, generally early in winter to midwinter. Molting usually doesn't occur during mating or migration.

Wing and tail feathers, responsible for flight, are replaced annually independent of body feathers. These feathers are molted at different times of the year, depending on the species. Broad-tailed and Broad-billed Hummingbirds molt wing and tail feathers at the end of summer, just before migration. Other hummer species molt them later while wintering in the tropics.

Hummers usually molt wing and tail feathers in a specific order. For example, they will drop two feathers at the same time and in the same location on both wings. Each wing has 10 primary feathers, which are used for flight. Ornithologists number primary flight feathers from the inside going out, with the number 10 primary, called P-10, at the wing tip position. These feathers are also replaced in order from the inside going out. Thus, when the P-2 feather on the left wing is shed, P-2 on the right will be, too. The absence of primary feathers can be seen only when using high-speed photography of in-flight hummers.

Hummingbirds have 10 tail feathers that grow in pairs on opposite sides. These feathers, called rectices, are molted in the same pattern as primary flight feathers. They are also replaced symmetrically on each side, but starting with the outside feathers. As each feather pair is dropped, a new pair grows in its place. This pattern continues working inward. Sometimes a hummer will molt all of its tail feathers simultaneously. This doesn't stop the ability to fly, as you might think. Hummers continue their normal flying activities and apparently do well, at least temporarily, without their tail feathers.

Hummingbirds in their first year molt once, obtaining their adult plumage by their first winter. One-year-old hummers returning to North America to breed look just like the adults.

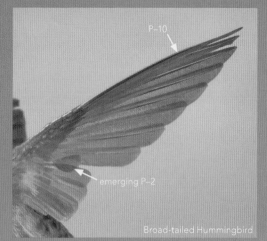

P–10

emerging P–2

Broad-tailed Hummingbird

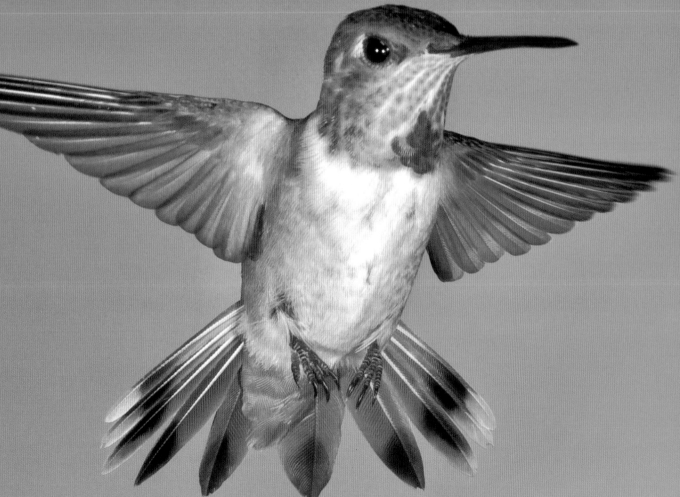

Allen's Hummingbird

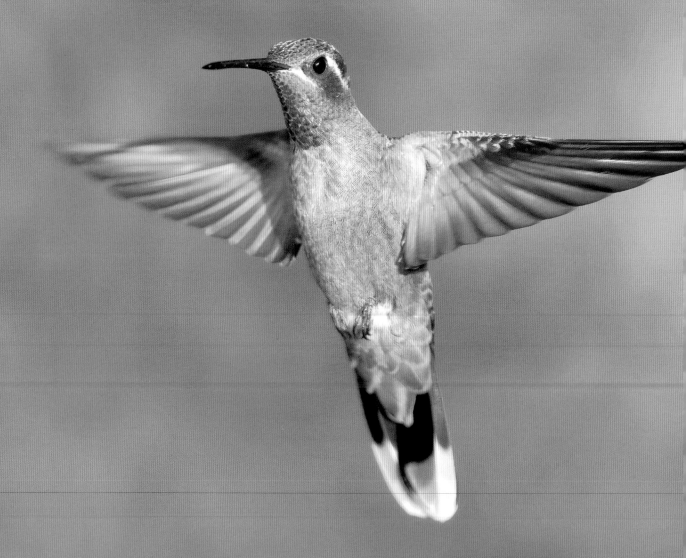

Blue-throated Hummingbird

Masters of flight

No bird has more mastery in flight than the hummingbird. Because of its diminutive size, a hummingbird can perform stunning flight maneuvers that other bird species can only dream about.

To power regular flight, a Ruby-throated Hummingbird will flap its wings up to 80 times per second. Flapping increases to 200 times per second during courtship flights. The extremely fast flapping moves so much air that it causes humming sounds. The tinier hummers, such as Calliope Humming-birds, need to flap constantly to remain airborne. Larger hummers, such as Blue-throated Hummingbirds, can actually glide silently on open wings without flapping.

Most hummingbirds can fly up to 20–30 mph during normal flight. During specialized courtship flights, hummers can reach 40–60 mph. Hummers not only fly forward, they also fly backward, side to side and even upside down! The last feat is accomplished by spreading the tail feathers as an air break and somersaulting.

Flight in hummers is achieved with the help of a large muscle in the breast called the pectoral muscle. This muscle accounts for 25 percent of their total body weight. The pectoral muscle in people is much smaller, accounting for less than 5 percent of our total body weight.

Extraordinary heart

Compared with other birds, the hummingbird has the largest heart in proportion to its body. Even so, it represents only 2.5 percent of the total weight. The resting heart rate is a zippy 500 beats per minute, which equals around 8 beats per second. Hummingbirds normally breathe an incredible 250 times per minute. When chasing rivals and performing courtship flights, respirations and blood pressure increase dramatically due to the racing heart, which can reach an astonishing 1,200 beats per minute!

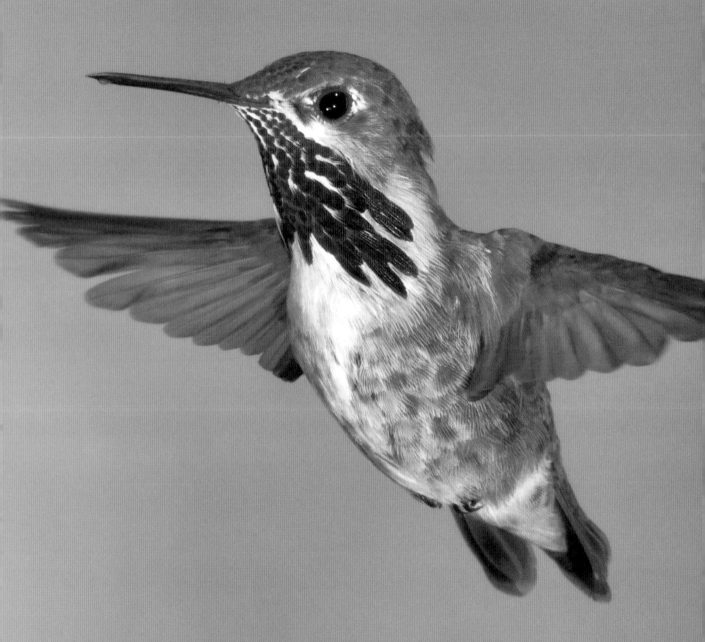

Calliope Hummingbird

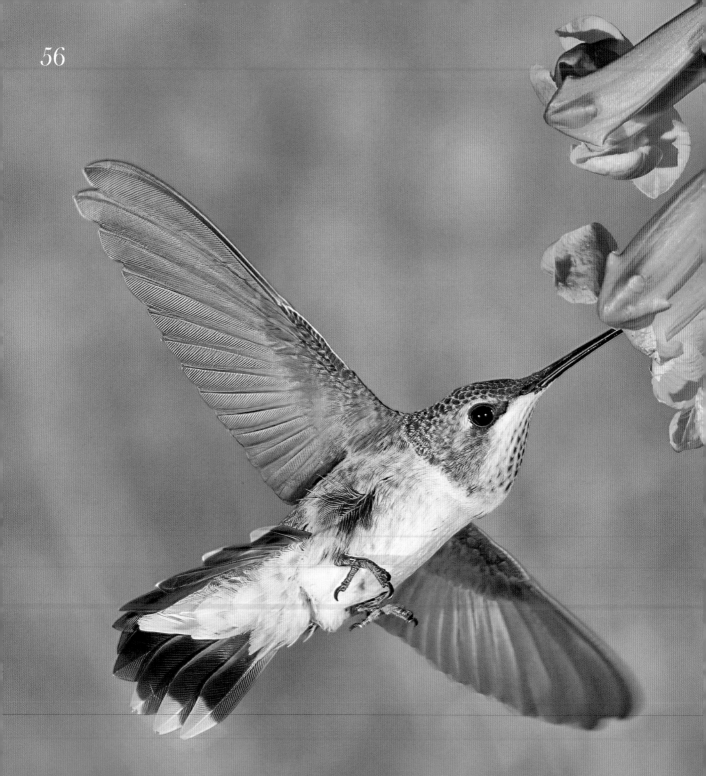

Black-chinned Hummingbird

Eye-catching sight

Hummingbirds have very tiny eyes, but enjoy excellent eyesight. Their eyesight is so exceptional, some estimate it is twice as good as the eyesight in people. They see the same things we do in the full range of light, and also other items visible in ultraviolet light that we cannot see. For example, a tubular red flower may appear to us to be one color, but hummers see a red flower and dark lines inside the flower's throat, pointing the way, like street signs, to the nectar source. It is the ability to see in ultraviolet light that enables hummers to make out these fine nectar guides in flowers and so much more.

It's important to appreciate here that hummingbirds do not feed only from red tubular flowers, as is commonly thought. Hummingbirds feed from many different blossoms of various shapes and colors, all of which are found by sight, not fragrance.

All hummer species find food and the material to build nests by eyesight. It is with the sense of sight that they locate bright flowers for nectar and spider webs and lichen for nest construction. They also hunt tiny insects by sight without using their sense of hearing.

Eyesight also plays a major role in mating. Males are brightly colored to show off to the females. A more vivid and sparkly male indicates a healthy, well-fed hummer with good genetics. Brighter males have a better chance of winning the heart of a potential mate.

Bill bending

The bill, or beak, of a hummingbird is a marvelous combination of form and function. Long or short, curved or straight, it's perfect for sipping nectar. Hummers with long, curved bills favor long tubular flowers. Others with shorter, straight bills, such as the Calliope Hummingbird, prefer shallow, broader flowers. Hummer bills are highly specialized and well suited to slip inside flowers that are dominant in the region. However, the birds can't live on nectar sugar alone. They also need fats, proteins and amino acids. When it comes to capturing and eating insects, the hummer's long, thin bill doesn't seem to be a great design—or is it?

Under laboratory conditions, several species of hummingbirds feeding on fruit flies were filmed using high-speed video cameras. Surprisingly, the birds caught flies in flight with the bottom of their bills, toward the base, not with the bill tips or by extending their tongues. This research revealed the interesting fact that at about midpoint along the length of a hummer's open bill, the lower bill (mandible) bends downward and widens, enlarging the catching surface and increasing the bird's chances of capturing an insect. Thus, the hummingbird bill is actually the perfect apparatus for extracting nectar and snapping up insects, with greater function from form than anyone previously imagined.

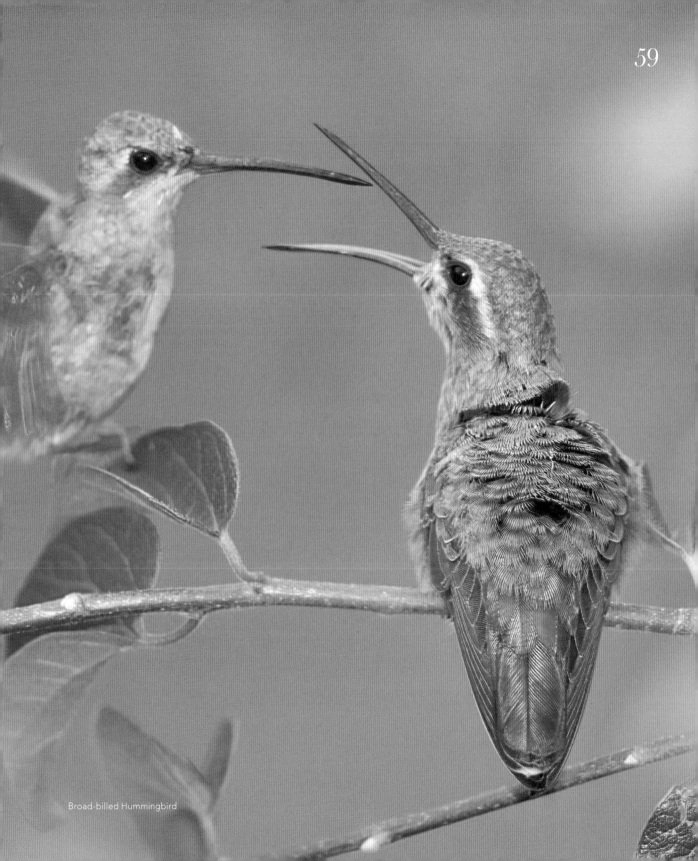

Broad-billed Hummingbird

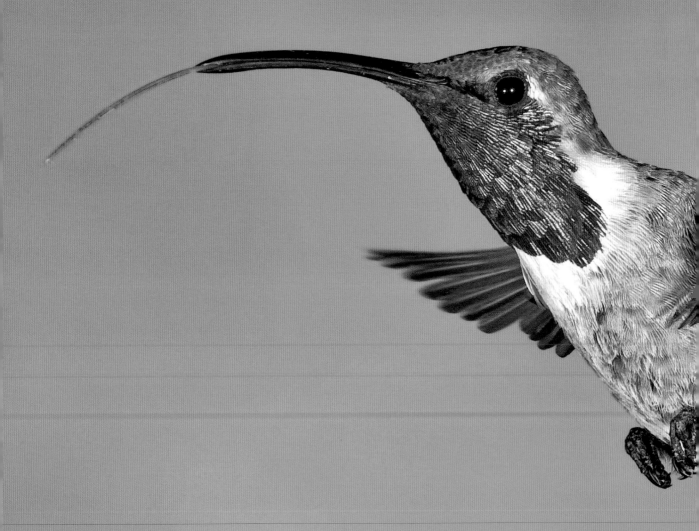

Lucifer Hummingbird

Grooved tongue

Hummingbirds don't suck nectar from flowers. Instead, they obtain nectar with their extremely long tongues, which have grooves along the sides. A hummer will dart its tongue in and out, up to 10 times per second, into the nectar source, filling the grooves with liquid. When the tongue is drawn back into the mouth, the grooves are squeezed into the throat and the bird swallows. It is common for a hummingbird to extend its tongue completely out of its beak several times after feeding to help clear any nectar residue from the grooves. Grooves are cleansed while perched or in flight.

High-speed digestion

Hummingbirds are amazing little birds that live life in fast forward. Each day they consume approximately 5-6 grams, or about 1/5 ounce, of nectar—a liquid amount around twice the weight of a Calliope Hummingbird. Their digestive system processes nectar so quickly that most of the liquid passes through in about 20 minutes. Nearly all sugars are efficiently extracted from the nectar, leaving a large amount of water. While the high-energy sugar fuels the high-speed actions of the hummer, only a small amount of water is needed for normal processes such as respiration and cooling. The majority of the water left needs to be eliminated.

Birds that don't consume as much water as hummingbirds have highly efficient kidneys. Their system concentrates excess liquid into a whitish semisolid waste of uric acid—the familiar white bird droppings you'll often see. Hummingbirds, on the other hand, manage their water excess by excreting a clear liquid urine on a regular basis, which usually goes unnoticed. They routinely defecate just at takeoff.

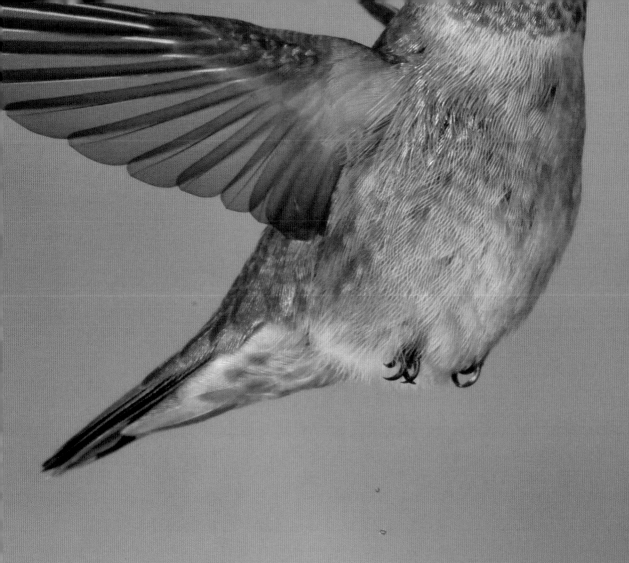

Broad-tailed Hummingbird

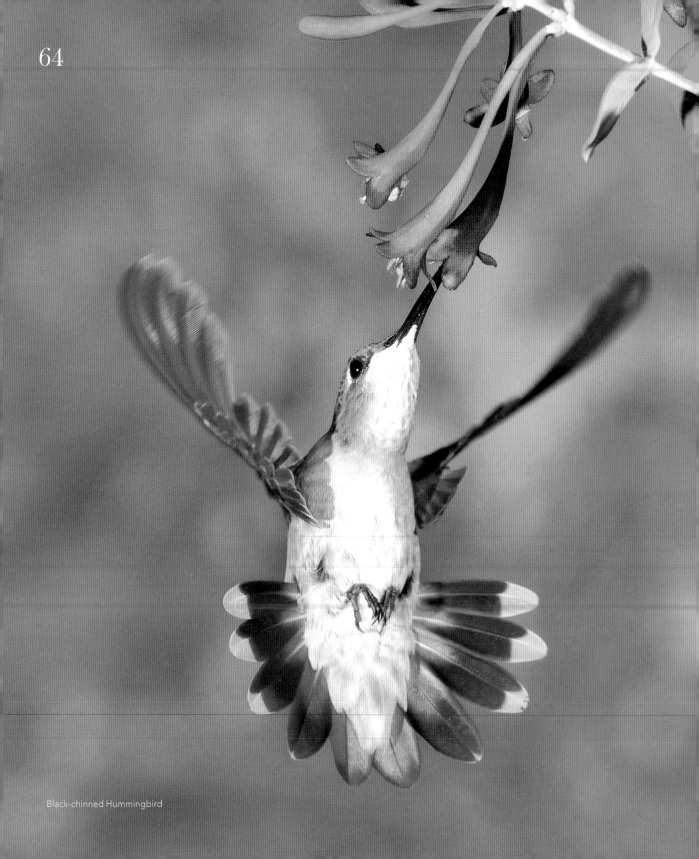

Black-chinned Hummingbird

Energy in nectar

Hummingbirds are high-energy, acrobatic fliers that require an energy-rich food. Nectar is a power drink composed of water and sugars, mainly sucrose (which is also found in sugar cane and sugar beets), along with trace salts and nutrients. The average nectar in flowers has about 25–30 percent sucrose. This sugar-water proportion can be easily replicated for hummingbird feeders by mixing 4 parts water and 1 part granulated white sugar.

The average hummer must consume more than its own body weight of nectar daily, which requires thousands of visits to flowers or hundreds of stops at nectar feeders. Hummingbirds feed about 7–8 times per minute, with visits lasting up to 4–6 seconds. Given their energy requirements, it's easy to see why plenty of flowers and feeders are essential for nourishing these vivacious birds. It also shows how hummingbird feeders can help augment their diet.

Flower sweets

When it comes to selecting a flower for nectar, humming-birds use their eyes. Vivid flowers are investigated first. Studies have shown, however, that hummers ultimately choose nectar quantity and quality over flower color. In one study that lined up a number of nectar feeders with gradually increasing sugar concentrations, hummingbirds preferred the feeder with the highest sucrose content. Flowers of any color that produce more nectar with a higher sugar content will be the ones that hummers prefer.

Hummers also prefer sucrose over simpler sugars such as glucose and fructose. Flowers that are pollinated by hummingbirds produce nectar with higher amounts of sucrose. Other flowers that are pollinated by visiting bees and other insects make the simpler sugars.

Ruby-throated Hummingbird

Hummers and pollination

Most large flowers have both male and female parts. The male part contains the pollen. Most flowers need to have their pollen transported to another flower to produce a seed (cross-pollination). When a hummingbird visits a flower, it inadvertently picks up pollen and transports it to a different flower. Not all flowers are pollinated by hummingbirds. A hummer can sip nectar from a shallow flower without picking up any pollen.

Broad-tailed Hummingbird

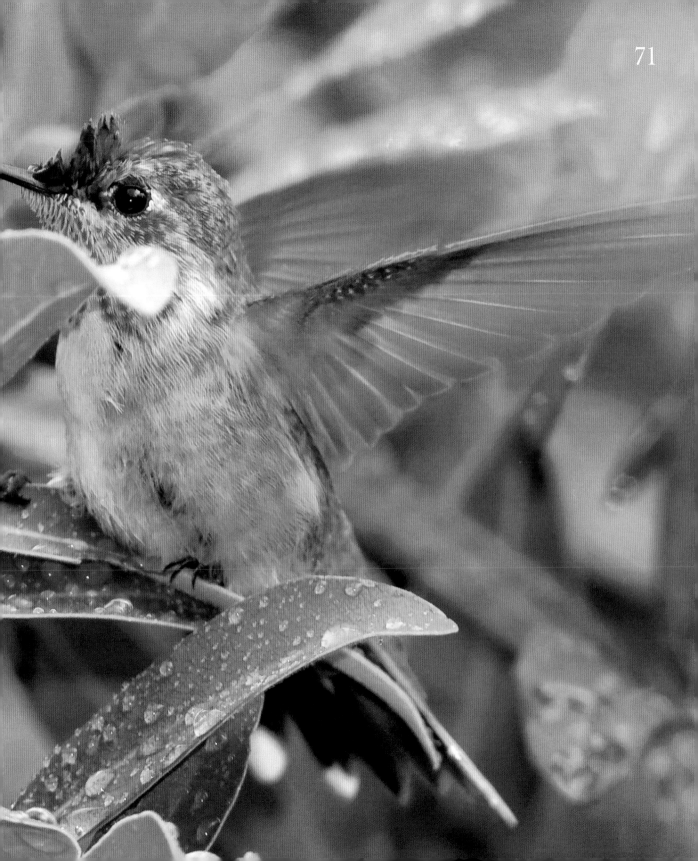

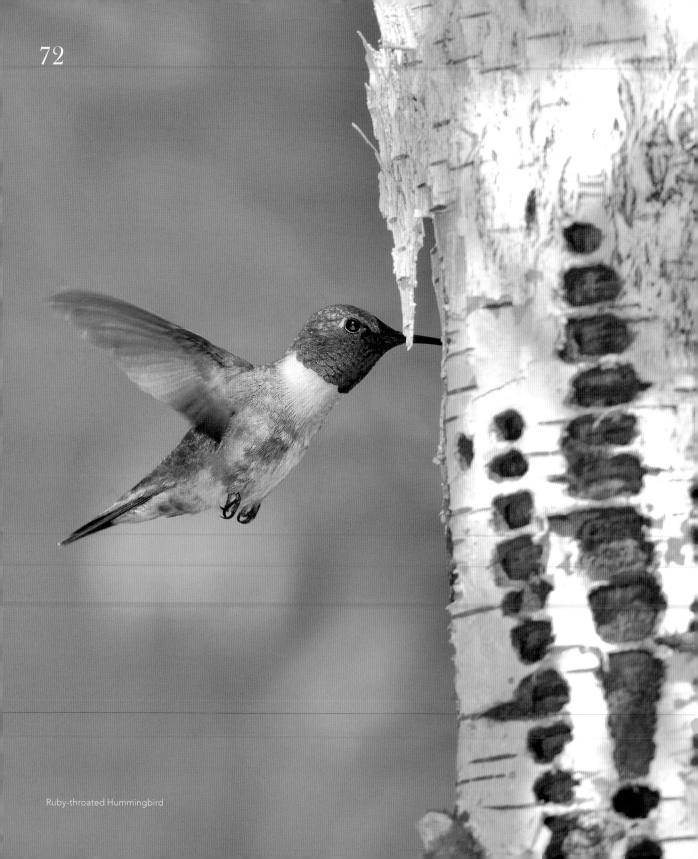

Ruby-throated Hummingbird

Hunting for insects

Hummingbirds can't live on nectar alone. Nectar is, after all, just a solution of water, sugar, some salts and trace essential nutrients that gives the birds quick energy. Insects are the important nutritional part of the diet. Nearly all hummer species feed on nectar at least in early morning and late in the day, but during the warmer daytime hours when insects are active, they feed savagely on gnats, fleas, aphids, tiny spiders and more. Insects provide the nutrients for everyday activities, as well as for egg production in females and muscle strength for courtship flights in males. Insect consumption increases when nectar is in short supply.

Sap taps

Sometimes tree sap provides another nutrition source. Any winter damage to a tree causes sap to leak out in spring. When Ruby-throated and Rufous Hummingbirds arrive at their northern breeding grounds early in spring before flowers bloom, they take advantage of this convenient source of sugar water. A series of holes in trees, called taps, drilled by Yellow-bellied Sapsuckers, provide not only woodpeckers with sap, but hummers as well.

Food tasting

It is widely thought that hummingbirds and most other birds lack a well-developed sense of taste. While the average human tongue has nearly 10,000 taste buds, a hummingbird's grooved tongue is believed to have only about 10 taste buds! Since taste and smell are always linked, limited taste buds would suggest that hummers not only have little ability to taste, but also a limited sense of smell. This makes perfect sense until you remember that hummingbirds prefer nectar with a higher sugar content. If hummers can't taste food well, how do they know which nectar is sweeter? It may be because all of their taste buds function together to detect sugar alone.

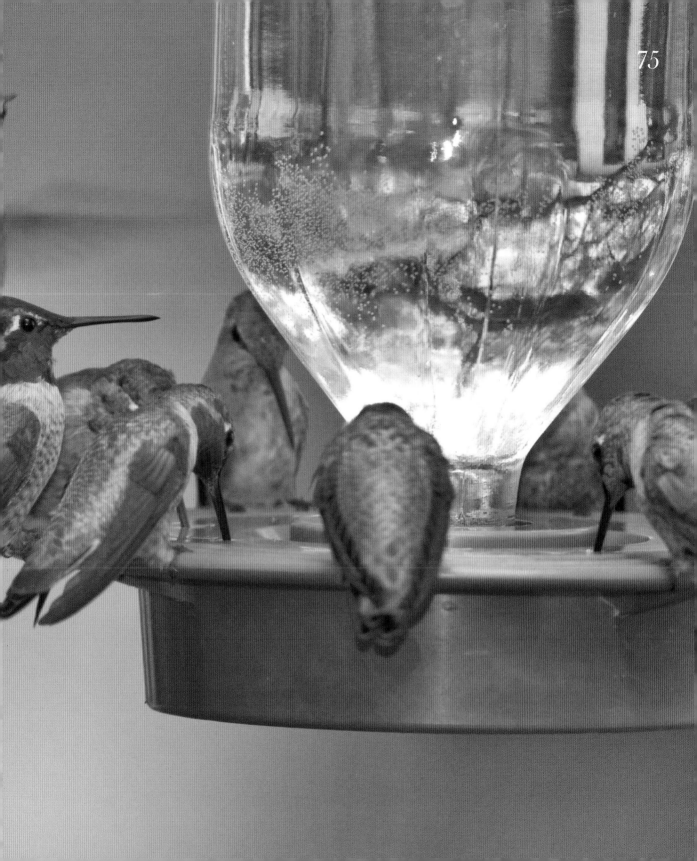

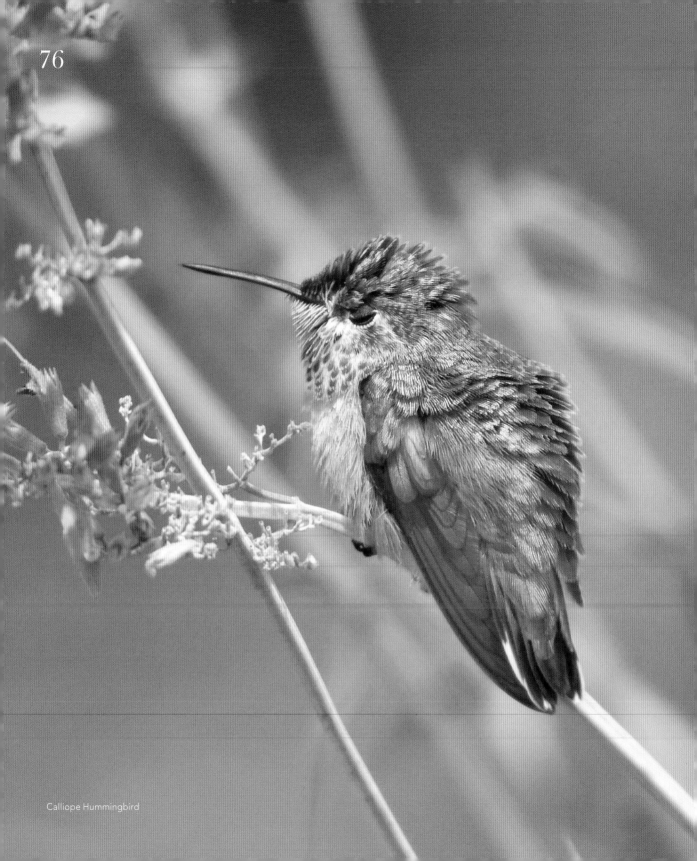

Calliope Hummingbird

Saving energy

Hummingbirds are like mini jet engines. They need a lot of energy to fuel their acrobatics such as straight-up liftoff. It is estimated that a hummer can starve to death in as little as 3–5 hours if it is active, but not eating. To sustain life, it needs to feed constantly. Although most of the food consumed fuels daily activities, a small portion is stored as fat. Fat is used as fuel for the body when the hummer can't forage for food, such as at night.

Storing enough fat each day is a delicate balancing act. Too much fat and the hummer can't fly. Not enough fat and it will run out of energy and die. To remain in balance, hummers feed heavily each evening, topping off their fuel tanks in preparation for a night without food. To help conserve energy and ensure that the fat will get them through the night, hummingbirds go into a state called torpor. Torpor (pronounced "TOR-per") is a short-term, modified hibernation that slows the body processes. In hummer torpor, the resting heart rate drops from around 500 beats per minute to about 50 beats per minute, respiration becomes so shallow that it appears to be nonexistent and body core temperature plummets about 10–20 °F. When a hummer goes deep into torpor, the bird becomes unconscious and is unable to move or defend itself.

Energy saving during torpor is estimated to be 20–30 percent over normal activity levels and means the difference between life and death overnight. At daybreak, when there is enough light to see, hummers are once again foraging for nectar or visiting feeders, replenishing the fuel that they need to survive.

Sunbathing fun

You may be fortunate on a sunny day to see a hummingbird on the ground, sunbathing. This behavior, seen more frequently in other bird species, is fairly uncommon in hummers and an unusual sight. When the sun is shining, a hummer will fly to the ground and lay flat, spreading out its wings, exposing its back and spreading its tail. In a sort of trance for the next couple minutes, the bird will cock its head from side to side, often with an open bill, as if stunned. Suddenly, it snaps out of it and takes flight, dashing up to a perch.

Sometimes you'll see a hummer sitting on a branch in full sunlight with its back to the sun, head cocked to the side and bill open. There it ruffles its feathers, exposing the deep recesses of its back to the light. Within minutes, it wakes up abruptly and quickly flies off.

Several theories attempt to explain the behavior. Some people think direct sunlight helps rid the bird of ticks, mites or other clinging insects. Others believe the bird requires extra sunlight to help convert food in the body into much-needed vitamin D. Still others say that warm sunlight soothes the bird's skin and aids molting. Because sunbathing probably feels good, it may, in fact, occur for a combination of reasons.

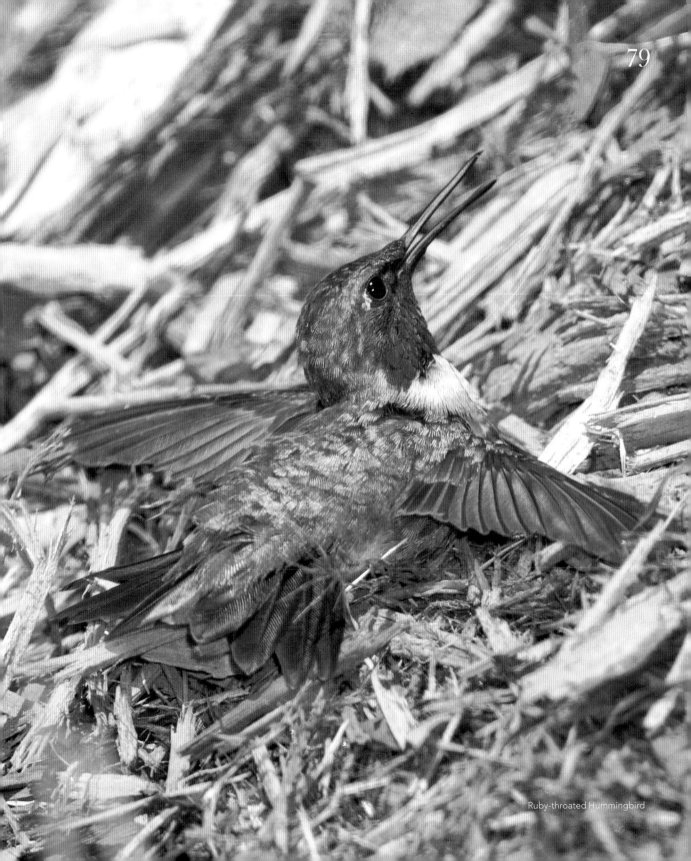

Ruby-throated Hummingbird

Broad-billed Hummingbird

Daily preening

Like all birds, hummers need to preen their feathers every day to keep them clean and in good working condition. Preening is a process that doesn't follow a pattern or regimen and is more like a nervous response. The average hummingbird has about 1,000 feathers, which include primary and secondary flight feathers, tail feathers, head feathers, well over 200 contour feathers (body feathers, giving shape to the bird) and down feathers under the contour feathers. Obviously, not all of these feathers will get preened in one sitting.

To begin, a hummer usually perches on a favorite spot and fluffs and ruffles its feathers, which loosens dirt and debris. Next, grabbing one feather at the base with its bill, the bird straightens and aligns it by sliding the bill along the entire length to the tip. The process of preening individual feathers occurs many times each day, with sessions lasting just a few seconds or continuing for a good long time.

Bath time

There are only two options for bathing—voluntary and involuntary. Voluntary baths require a visit to a shallow pool of water. Often this is a slow-moving, meager stream of water no more than ¼-inch deep. A hummer will cautiously take its time flying to the water source, looking for hidden predators. Eventually it makes a quick dive and skims the water's surface several times, taking a small amount of water into its breast and belly feathers, which it uses elsewhere for freshening up.

Hummingbirds rarely land to bathe. Usually landing occurs only when the water is just centimeters deep, giving no possibility for the bird to be washed away. Hummers sometimes land on shallow birdbaths with a miniature rim and very little water. Because their legs and feet don't function well to walk, a hummer will grip the edge and dip its bill and upper body into the water, splashing with its wings to soak the rest of its feathers.

Hummers are well known for taking a bath in a backyard sprinkler or mister. As long as the water stream is weak, hummers will zip back and forth through the spray before heading waterlogged to a favorite perch to preen. There are many commercially available sprayers made just for hummingbird bathing that install easily in your backyard.

Involuntary baths occur during thunderstorms. In a downpour, hummingbirds stop feeding and concentrate on bathing. It's fun to watch a hummer take a natural bath, which is actually more like a shower. All the bird needs to do is stretch out its wings and spread its tail feathers to catch the incoming rainwater.

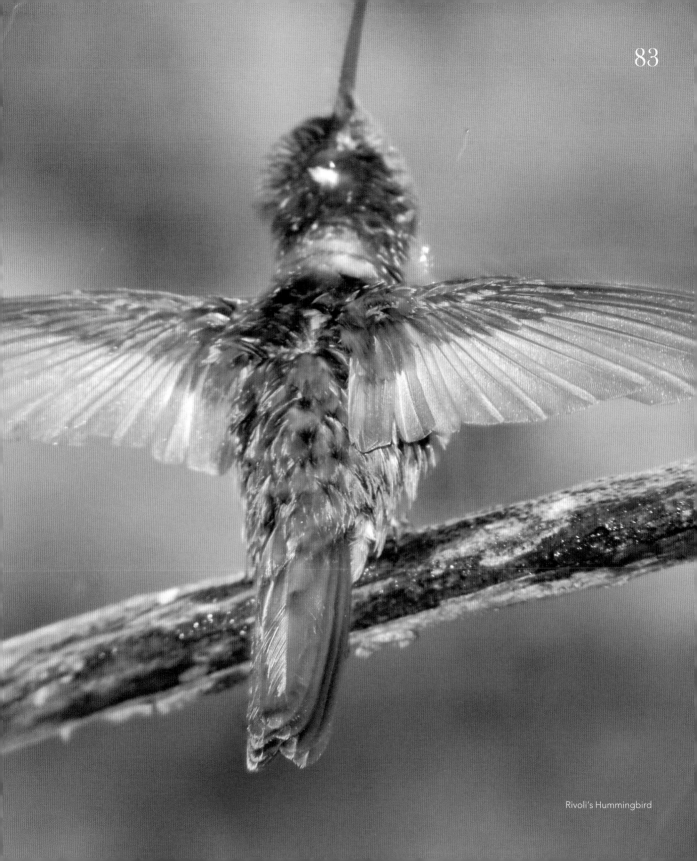

Rivoli's Hummingbird

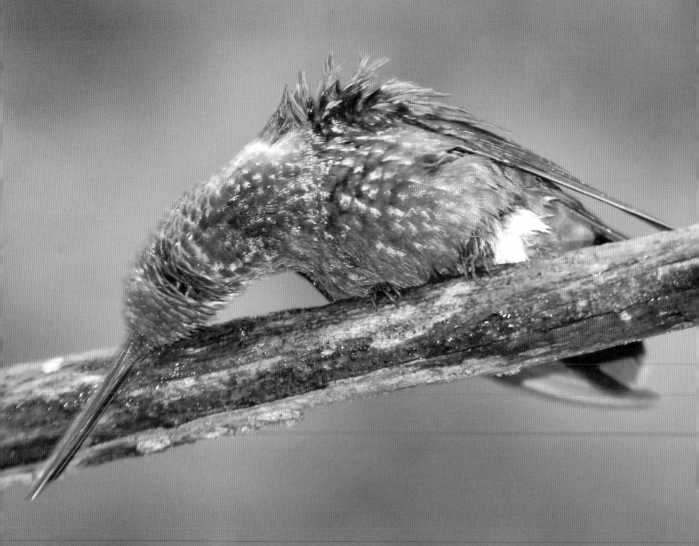

Rivoli's Hummingbird

As it preens, a hummer also cleans its bill by wiping it along a branch. This process is accompanied by feather fluffing and a lot of shaking, which expels any trapped dirty water.

Sometimes hummingbirds wait until after a rainstorm to bathe. Immediately after rain stops, a hummer will fly to a large leaf that has a collection of water droplets on its surface. Grasping the leaf edge, the hummer will roll around on the surface of the leaf, mopping up the water. Once it has gathered the water into its feathers, it either moves to another leaf to get more or perches on a branch to start the preening process.

Call notes

Hummers are not virtuosos like the songbirds of the world. All 4,000-plus songbird species have vocal organs that produce musical notes. Songbirds also use calls, which are typically single nonmusical notes that convey specific information to other birds. Only a few hummingbird species can sing, and their songs are rudimentary at best. A hummer's glittering appearance and spectacular flight are more than enough to amaze without the aid of song.

Hummingbirds make chittering and chattering sounds. Some even give a high-pitched squeak. Each of these sounds is a type of call that the bird makes with its voice box, or syrinx. Hummingbirds issue call notes to communicate displeasure to other hummers during territorial disputes. A male will also call to woo a female during his courtship display flight. He produces a fast ticking noise, like an insect, while flying back and forth in front her as she watches from a perch.

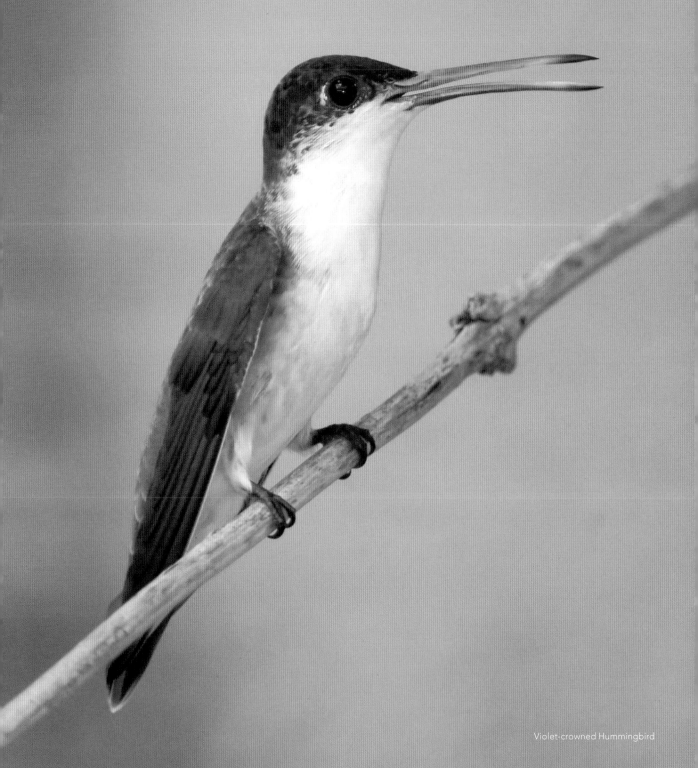

Violet-crowned Hummingbird

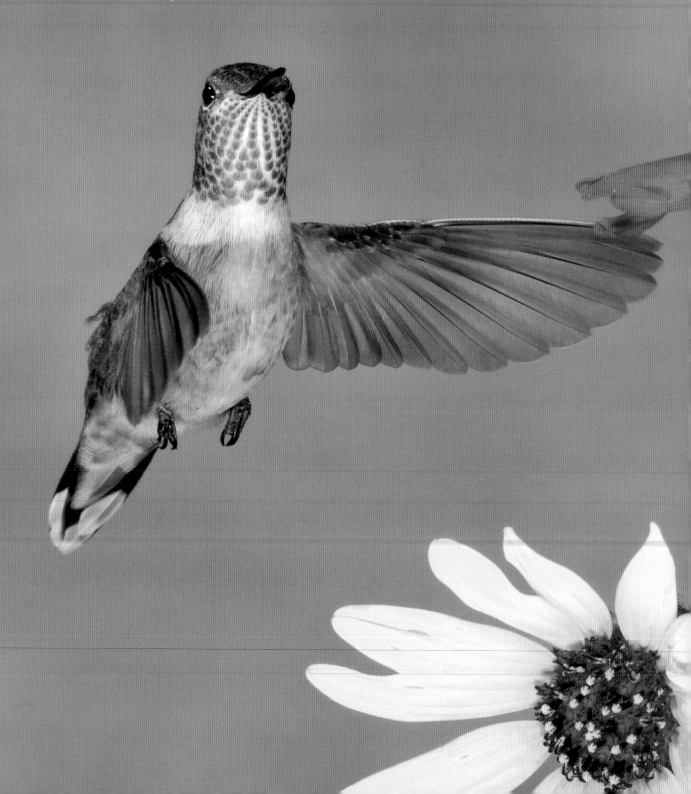

Wing singing

Males of some species go one step beyond making simple call notes. Broad-tailed Hummingbird males have a specialized primary wing feather that vibrates at a high rate, producing a sound that is similar to a tiny ringing bell. You can hear the bell-ringing of male Broad-tails loud and clear as they zip by. Juvenile male Broad-tails lack this feather and can't produce the sound. Male Rufous and Allen's Hummingbirds make other extra noises with their wings and are also fairly vocal. However, in many of the species in which males produce an additional sound with their wings, vocalized call notes are not commonly used or given at all.

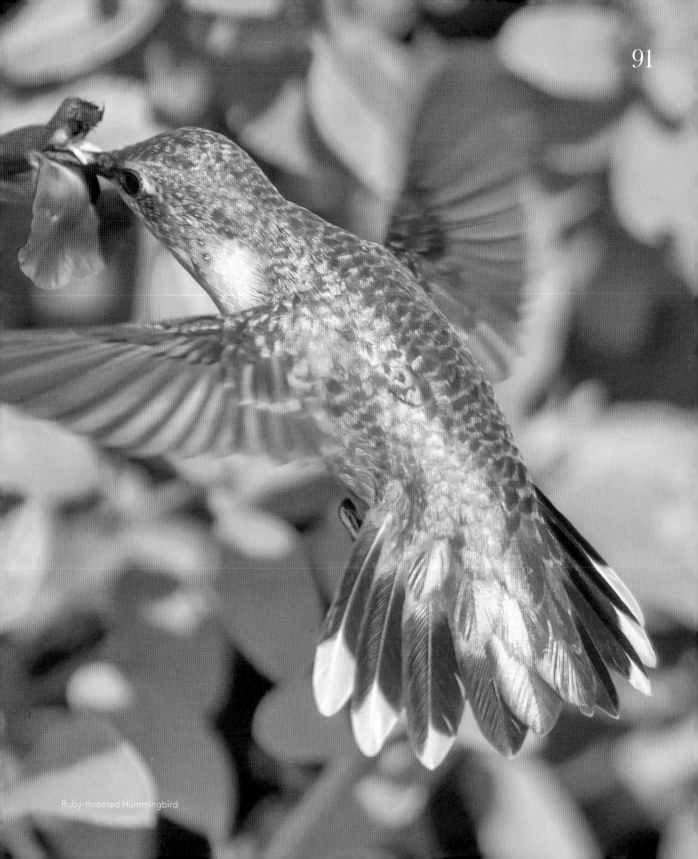

Ruby-throated Hummingbird

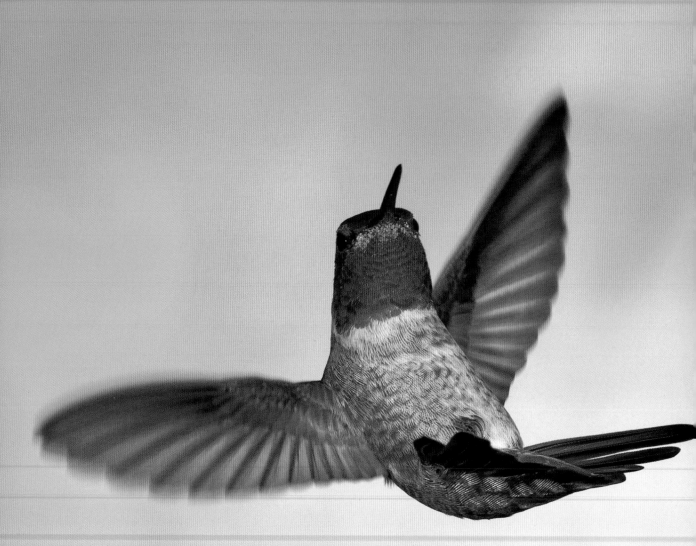

Anna's Hummingbird

Diving displays

In most hummer species, the males perform spectacular diving displays in front of a perched female. A male Ruby-throated Hummingbird, for example, will display for a perching female by rapidly flying in a U-shaped pattern. Each time he flies past her perch at the bottom of the U, he flashes his gleaming red throat patch (gorget) to impress her. With each succeeding flight, he rises higher, at times reaching heights up to 30 feet. All the while he makes chittering noises, sounding like a buzzing insect. As long as the female stays perched, the male whizzes back and forth and up and down, continuing to charm her with his flickering display.

Sometimes a male Ruby-throat will perform a tiny U-shaped flight display only 10–12 inches in height, accompanied with softer, less intense chittering. These are more intimate performances, given when a female is receptive and ready to mate.

Black-chinned and Broad-tailed Hummingbird males also perform fabulous U-shaped dive displays for females. Other species, such as the Calliope Hummingbird, perform aerial displays in the same U pattern, but Calliope males fly as high as 60–90 feet to dazzle a potential mate. Costa's Hummingbird males fly in large ovals while vocalizing, just like male Rufous Hummingbirds. On the Pacific Coast, the male Allen's Hummingbird display resembles a U with a curly-Q ending, with flights up to 100 feet, followed by a nosedive to start all over again. Another western coastal hummer, the Anna's Hummingbird, flies in more of a J-shaped design, with males streaking up as high as 120 feet. All of these breathtaking extravaganzas show the female that the male is fit, healthy and able to sire exceptional offspring.

More than bravado

Hummers are tough little birds, big with attitude. Anyone who provides a nectar feeder for hummingbirds knows they are not congenial birds. In fact, they are downright aggressive, even violent. All species are fairly antisocial and belligerent, with hostile behavior resulting from limited supplies of food.

Hummingbirds can starve to death within a matter of hours without food. They not only need to feed frequently, they also must protect their precious food supply. If a patch of flowers is the sole nectar source, it is in a hummer's best interest to chase off other hummers and nectar-feeding insects such as bees. The best way to accomplish this is to rush at the intruder, using the element of surprise, and chase it away. An individual often will try to land on a pilfering hummer and rake its back with the feet. It also uses the bill as a sword to jab the interloper.

Trespassers will usually flee, but sometimes there is a squabble and a fight. Fighting often occurs between two males. Females are also combatant, especially at the end of summer when adult males begin to migrate—which results in outnumbering by females and juveniles. A jealous adult female will attempt to drive off the remaining adult males in the area to claim a nectar feeder for herself. Hummingbirds are so protective of their food source, they even harass and courageously chase away larger woodpeckers and other birds more than twice their size.

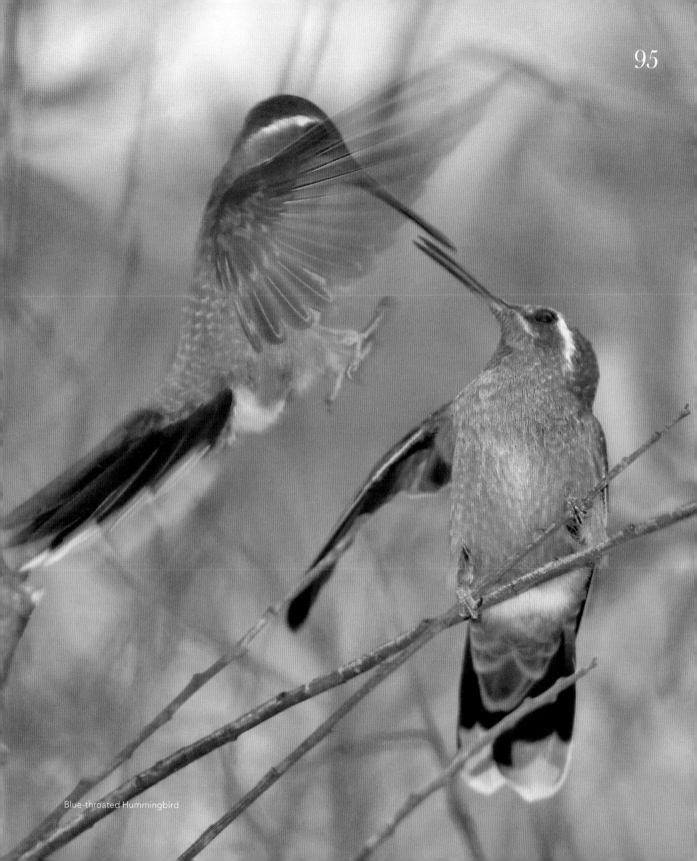

Blue-throated Hummingbird

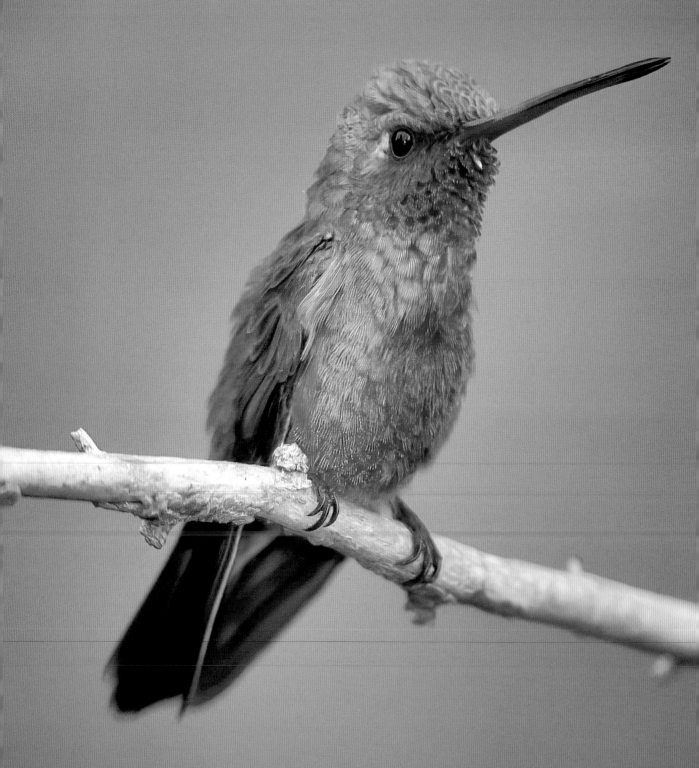

Territory

Territories tend to be fairly small in all hummingbird species—normally less than ¼ acre. Size depends on food availability and is not as important as the type or number of nectar-producing flowers in the area. Some territories are very small, consisting of a single plant or shrub with many flowers. When many nectar-producing flowers are in an area, hummers will defend small territories. Where flowers are few and far between, territories are much larger. Sometimes a dominant male will claim a large area and try to defend it from all others despite the great cost in energy. Other times, a hummer will claim a nectar feeder as its main food source and attempt to chase off all feeder birds regardless of the species.

During breeding season, males and females hold separate territories with only slight overlap, if any. When the cost of defense gets too high, a resident may conserve energy by allowing some hummers to feed while continuing to chase out others.

Hummingbirds defend territory from a perch that offers the best overall view. A hummer will sit for long periods, swinging its head back and forth, looking for intruders. The moment it sees one, it charges and attacks with the feet or the bill. Either way, this usually results in a chase of a few feet or continues well out of the territory. When the territory is clear, the resident bird returns to its perch to watch for the next trespasser.

Migration

Much of migration remains a great mystery to science. While we can only speculate how it started and why it continues, there are a number of facts we know. Migration allows an expanded bird population, including hummers, to exploit food resources and breed elsewhere. Nearly all species of hummingbirds in the United States travel thousands of miles to find food and reproduce, and they face intense competition from others of its own kind. Ruby-throats, for example, fly north after wintering in the tropics of Central and South America and fan out in spring across the eastern United States, where they find many sources of food and breeding opportunities. We also know that hummers return to the region where they hatched. Ruby-throats hatching in Missouri will return to Missouri the next year. Others hatching in Michigan will return to Michigan. Once at the breeding grounds, hummers look for a suitable territory with enough food to sustain themselves for the entire summer.

Hummingbirds are so small that they often will not migrate on days with a strong headwind. They average approximately 25–30 mph when there is no headwind and increase their speed with a tailwind. Recent studies show that the return north in spring goes much faster than the trip south in fall. Since the first hummers to arrive at breeding areas are likely to be more successful, this may cause the birds to exert extra effort during the spring trip. It is thought that most migrate about 200–500 feet above the ground when they are trying to make serious mileage.

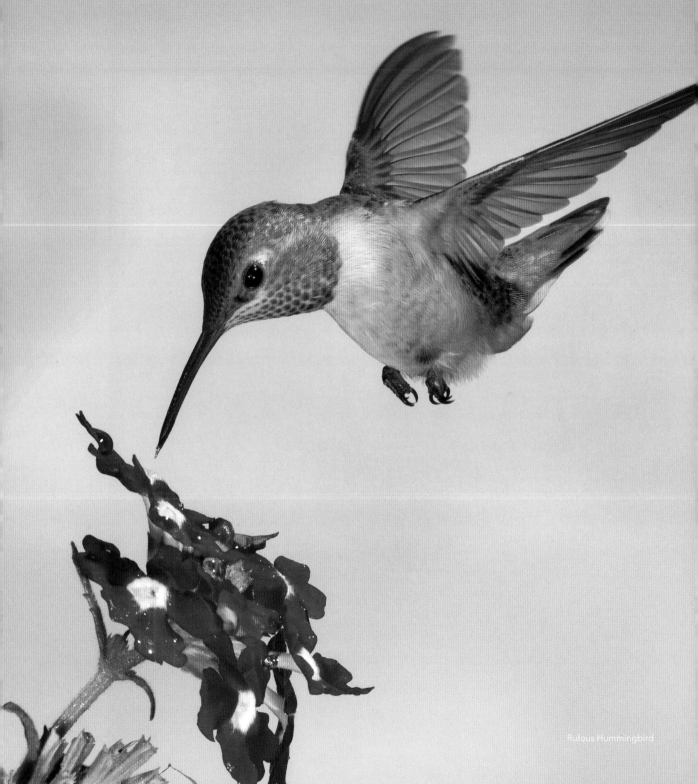

Rufous Hummingbird

Berylline Hummingbird

No free rides

Some people mistakenly think that hummingbirds migrate by hitching rides on the backs of geese. This is a silly old myth that probably started with the idea that a tiny bird could never fly great distances on its own—a notion that is simply not true!

Hummingbirds are true neotropical migrants, which means they fly to the tropics for the winter. Geese, on the other hand, migrate just far enough south to find open water, typically a distance of only a couple hundred miles. In northern states, geese often move just to the middle of the country where water stays unfrozen all winter. Hummingbirds fly thousands of miles beyond this point. They also migrate earlier, departing well before geese get the urge to leave.

Time to leave

Hummingbirds migrate each fall when their bodies tell them to go, no matter what. You might even say that they are slaves to their hormones. Once the hormones trigger, the hummers migrate. While it is true that weather, sky conditions and many other factors influence migration, hummingbirds don't migrate because of lack of food, as some think. It is the length of daylight in autumn and spring that triggers hormones, which causes hummers and other birds to migrate.

Nearly all birds get their cues to migrate from the total amount of daylight on a given day. This time is known as the photo period. Birds perceive the amount of daylight through their skulls directly into the brain. In mammals, light cues pass through the eyes first before going into the brain.

As days start getting shorter in fall or longer in spring, birds sense the photo period change. When the length of day matches the migration photo period, changes occur in the birds. Hormones begin to surge, and the birds respond with agitation or restlessness. This behavior is called migratory restlessness, or *zugunruhe*, from the German *zug* ("migration") and *unruhe* ("restlessness"). In this condition, birds change from being active mainly during the day (diurnal) to also being active at night (nocturnal). Nocturnal activity is necessary because nearly all hummingbirds and songbirds migrate at night.

As day length changes and the optimal time to leave approaches, the hormones surge even more, at last prompting the birds to fly away. These hormones continue circulating in the body during migration and propel the birds along. In most species, migration stops when the hormones subside. Occasionally a single hummer won't migrate. This may be due to a defect in the individual's endocrine system, which causes hormonal dysfunction. Nature usually takes its course in this case and the hummer does not survive.

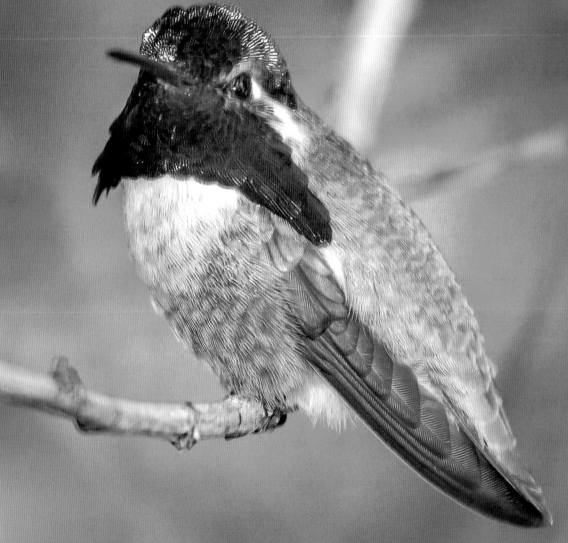

Costa's Hummingbird

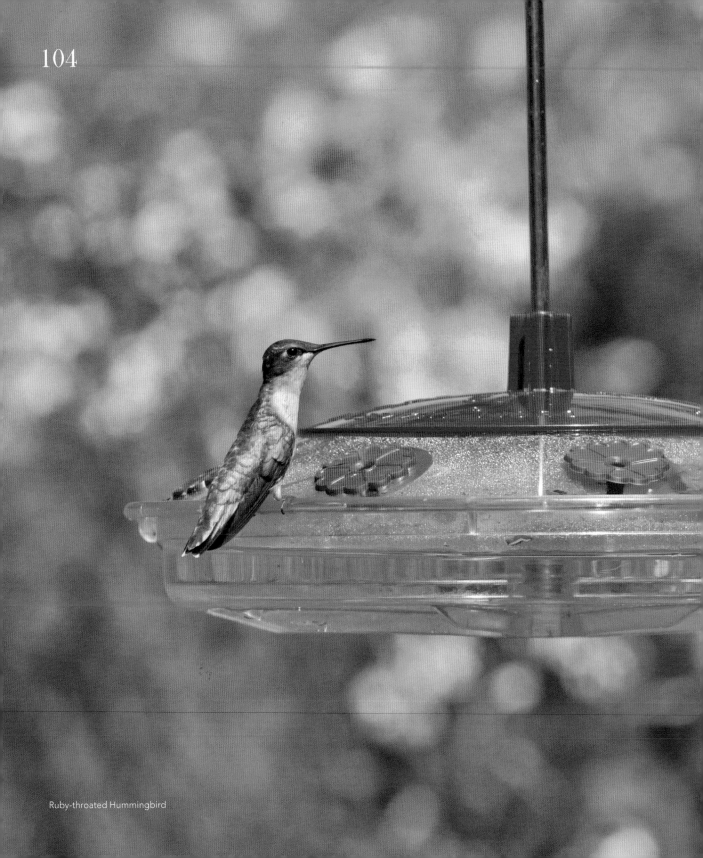

Ruby-throated Hummingbird

Feeder rest stops

Many people erroneously believe that nectar feeders must be taken down at the end of the season to force hummers to migrate. This idea is not based on fact, and actually the reverse is true. Nectar feeders need to be left out well after you have seen the last visitor.

Some estimate that hummingbirds almost double their weight just before leaving. For resident hummers, feeders provide an essential source for bulking up with calories before migrating. For nonresidents, finding your feeder along the migration route may mean the difference between life and death. The number of nectar-producing flowers is greatly reduced in autumn, limiting opportunities to find food in the wild. Feeders offer a vital oasis during times of need in fall. The same is true for the return trip, so be sure to put your feeders out before our petite friends are scheduled to arrive in spring.

Migratory feats

One of the most impressive feats of flight in humming-birds is the migratory journey. Hummers are solitary birds that migrate on their own, not in groups. During fall migration, many Ruby-throated Hummingbirds in the eastern half of the country fly individually to coastal Texas, where they prepare for the most dramatic leg of their trip. After reaching the Gulf coastline, they feed heavily while waiting for optimal weather conditions such as winds from the north. One evening as the sun sets, the hummers take off one by one for a long, lonely flight over the waters of the Gulf of Mexico to the nearest land south—the Yucatan Peninsula in Mexico. This is a whopping 500-mile journey across open water with no place to stop and rest. For 18-22 hours straight, the hummers fly nonstop to reach the other side, where they land fatigued, to rest and eat.

Just as a car needs a full gas tank to drive to a destination nonstop, hummingbirds need enough fat reserves to fuel their flight across the Gulf. Too much in reserve and they will be too sluggish and heavy to fly. Not enough fat and they will run out of energy, drop into the ocean and die. About double the normal body weight appears to be appropriate weight for making the trip. While some skirt the Gulf of Mexico on their way south, the majority will make this dangerous, open water crossing. In spring, they repeat the long flight, going in the opposite direction.

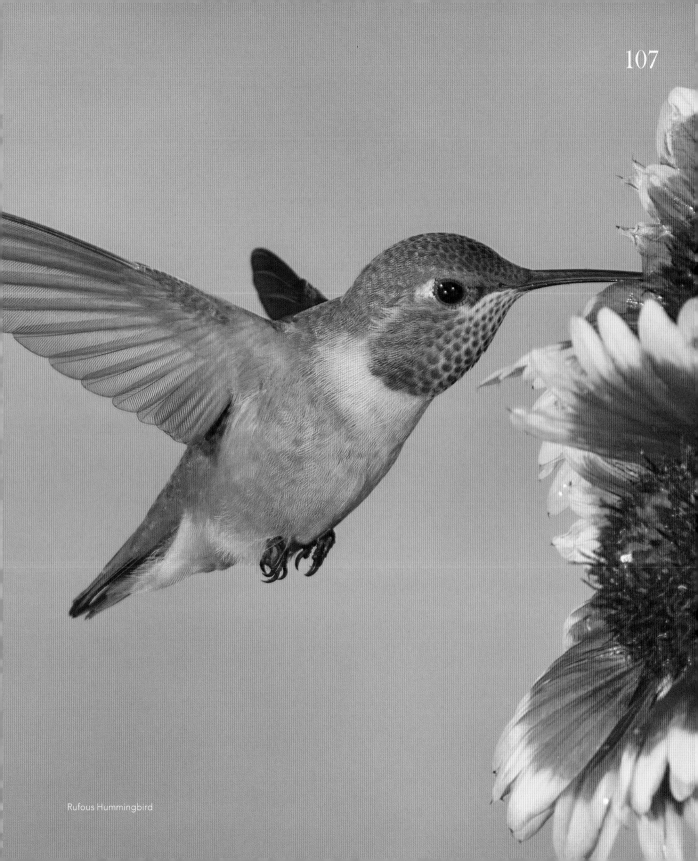

Rufous Hummingbird

Not all hummers journey nonstop across the Gulf of Mexico. Many western species fly just a couple hundred miles to and from their wintering homes. Some individual hummers—Allen's and Anna's Hummingbirds, for example—never leave southern California. Calliope Hummingbirds, on the other hand, navigate the high peaks of the Rocky Mountains on their way south to winter in Mexico. Other species in the western half of the country have different challenges. Some cross the Sonoran Desert. Others fly through the Chihuahuan Desert. High temperatures and a lack of flowering plants are the main obstacles hindering these migrators.

Rufous Hummingbirds migrate the longest distance. Starting from their winter homes in Mexico, they fly up to 3,000 miles across mountains to their breeding grounds in Washington, Canada and Alaska. After just a brief breeding season, these robust birds begin their arduous trip south. During the day, the need to search for food leaves time for only short rejuvenating naps. Full sleep and torpor does not occur during migration.

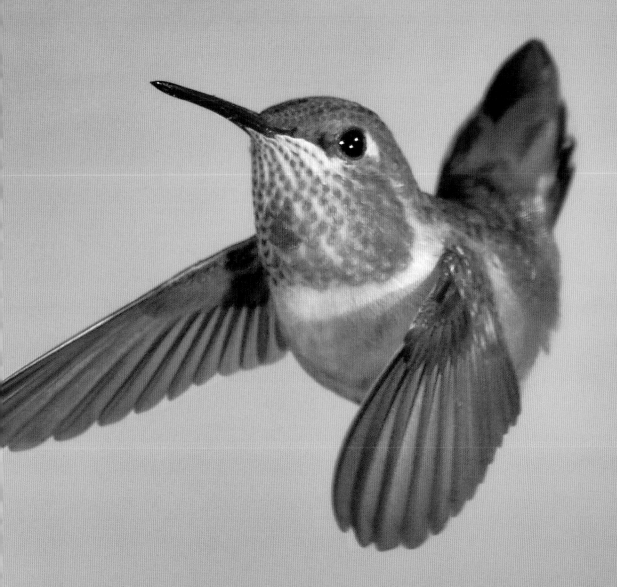

Rufous Hummingbird

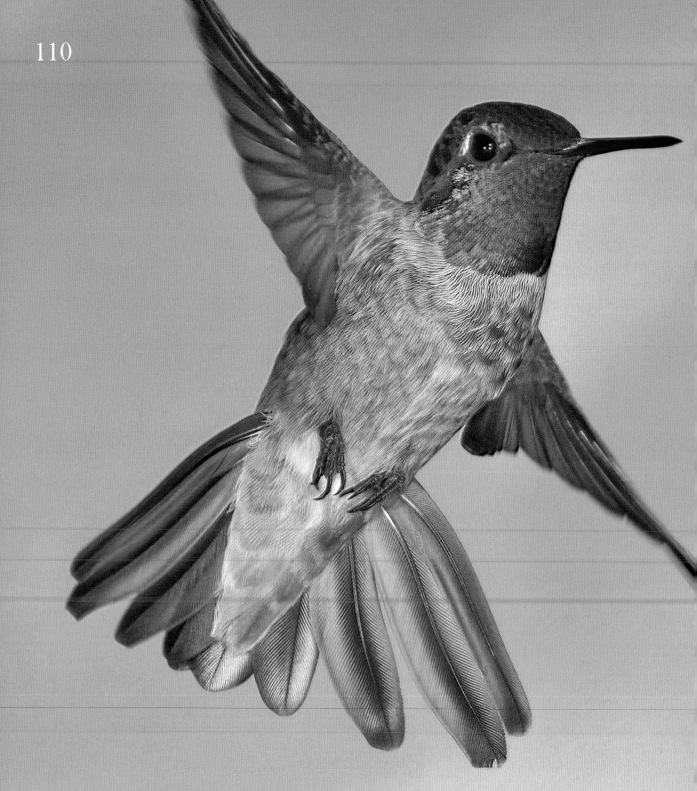

Anna's Hummingbird

Spring migration

Spring migration is timed to weather conditions and the flowering of blossoms that produce nectar. Black-chinned and Ruby-throated Hummingbirds are among the most common long-distance migrators. They advance about 20 miles each day. When flowers are unavailable, the hungry early arrivals raid Yellow-bellied Sapsucker taps. Sapsucker woodpeckers drill a series of holes (taps) in live trees. Taps leak tree sap, which contains sugar, just like nectar. Early flying insects are also attracted to taps in spring and provide another source of food for the hummers as they feed on the sap.

Breeding ground arrivals

It seems like a miracle when the hummingbirds make it back each year. The chances look slim that these teensy birds could cross great distances with so many impediments such as unfamiliar territory and scant food. Yet with each migration, they beat the odds of survival and perpetuate the species.

Adult male hummingbirds are the first to migrate and the first to arrive on breeding grounds. Many Internet websites track the northward migration of Ruby-throats in the East and Rufous Hummingbirds in the West. Watching their progression on website maps is a fun way to anticipate the return of your resident hummers. Online tracking will also alert you to hang your nectar feeders so the hungry migrators will have something to eat when they turn up exhausted from their travels. Putting up feeders may also convince a male hummer to adopt your yard as its territory, where you can enjoy its presence all summer.

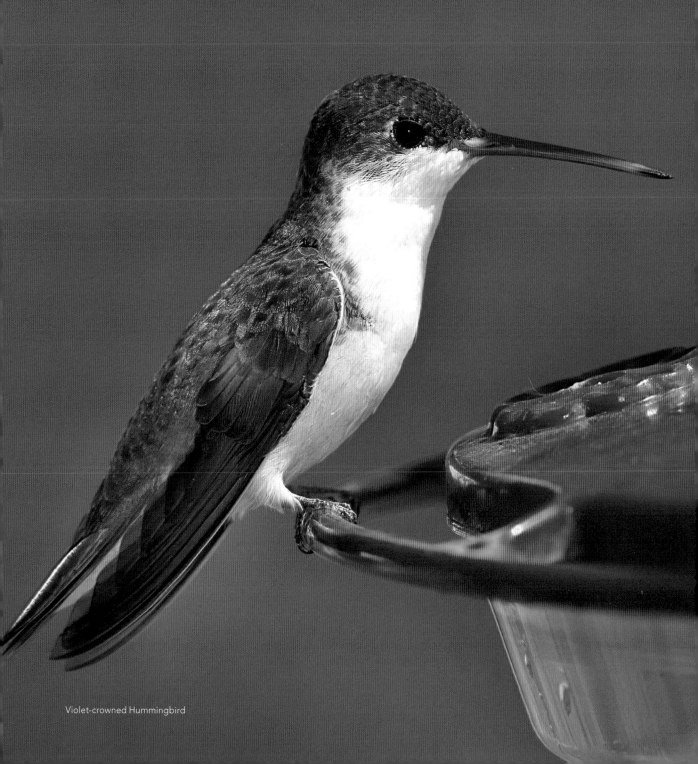

Violet-crowned Hummingbird

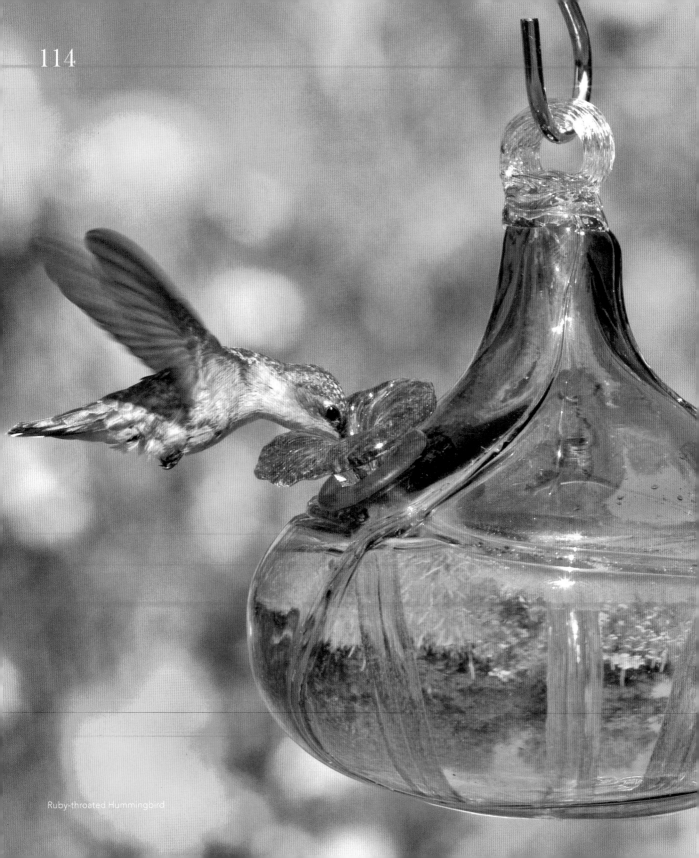

Ruby-throated Hummingbird

Where's that feeder?

Hummingbirds have astounding memories. Hummers that called your yard home and your nectar feeder their own usually return. They will go to the exact spot where the feeder hung during the previous year and buzz around looking for it. If you don't have your feeder out before they arrive, they will spend a lot of time trying to find it. Some people have reported hummers flying up to their windows and looking inside as if to say, "Hey! I am here! Where's the feeder?"

Hummers remember your feeder as a good, constant source of nourishment and they are desperate to refuel at the site when they return. The anxiety of hungry hummingbirds sends bird-loving homeowners scrambling to mix sugar-water solution, get their feeder out of storage and put the food out as fast as possible. It doesn't take the hummer but a few minutes to start sipping once the feeder is outside for the season. To avoid this mutual distress, be sure to have your feeders cleaned, filled and hung before the hummers arrive.

Establishing a territory

Male and female hummingbirds establish and defend separate territories. While songbirds announce and defend territories by singing, hummers are birds of bolder action, defending territories with physical engagement and by flashing colors in flight. When a hummingbird enters occupied territory, the resident hummer swiftly flies over to give chase. The occupant of the territory from the previous year usually has the advantage in the current year. However, if the resident from the preceding year doesn't return from migration, the area is quickly claimed by a new resident. Once established, the new resident finds a prominent perch with a good view of the area. There it will spend many hours sitting in defense, swinging its head from side to side, watching for intruders.

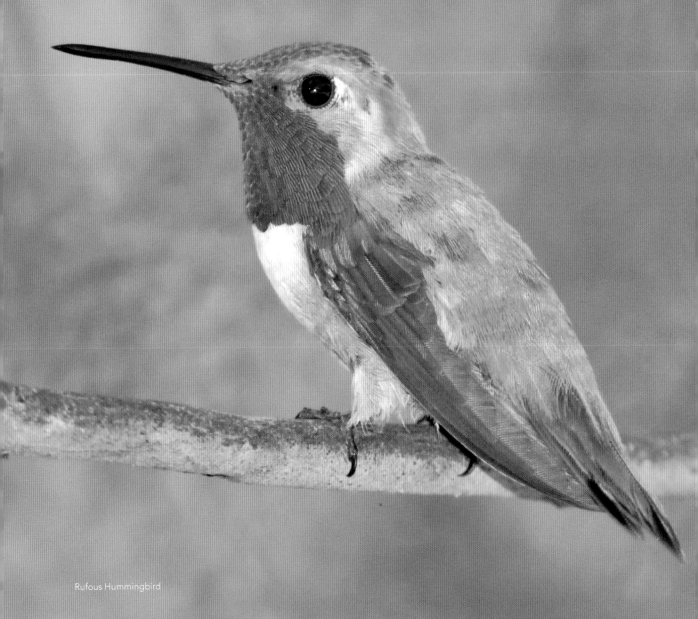

Rufous Hummingbird

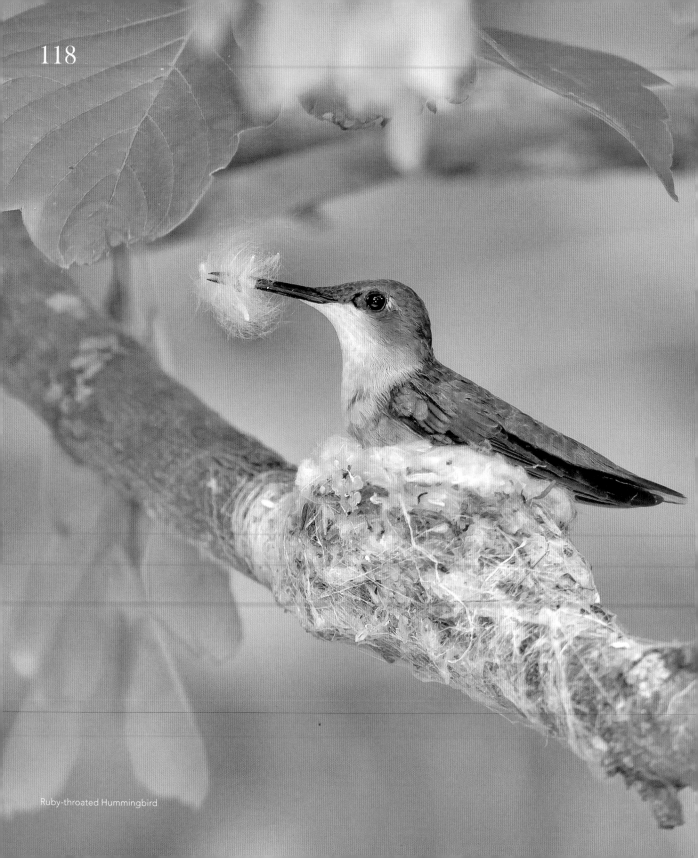

Ruby-throated Hummingbird

Nest construction

Building a nest is the sole responsibility of the female. Before she mates, a female hummer will build her nest, starting with the choice of a site. Often this is on a small horizontal branch. While other birds take advantage of natural forks in branches, female hummers frequently build in the middle of a branch. The nest site is selected on the basis of success during the previous year. If a female had success with a nest low to the ground over a stream, she will normally make a similar choice the following year. Females sometimes return to the same branch of the preceding year and construct a nest next to the old one or simply build over it.

The construction work begins with the collection of sticky strands of spiderwebs. Using her bill, the female attaches the webs to a branch. Next she collects cattail down, cottonwood tufts or other soft plant material and sticks those to the spider web pad. She continues this process, constructing the entire nest with one bit of material at a time. Standing in the nest, she shapes the interior and forms the cup with her chest and belly.

Usually a comfortable lining is prepared with soft plant material such as cotton from cottonwood. For the finishing touch, the female camouflages the nest, adhering bits of lichen and tree bark to the exterior to make it match the surrounding branches. No matter what the tree branch looks like, she will choose nesting material that matches the tree to provide the perfect disguise. Depending on nest building experience and availability of nesting material, construction takes 4–8 days, from start to finish.

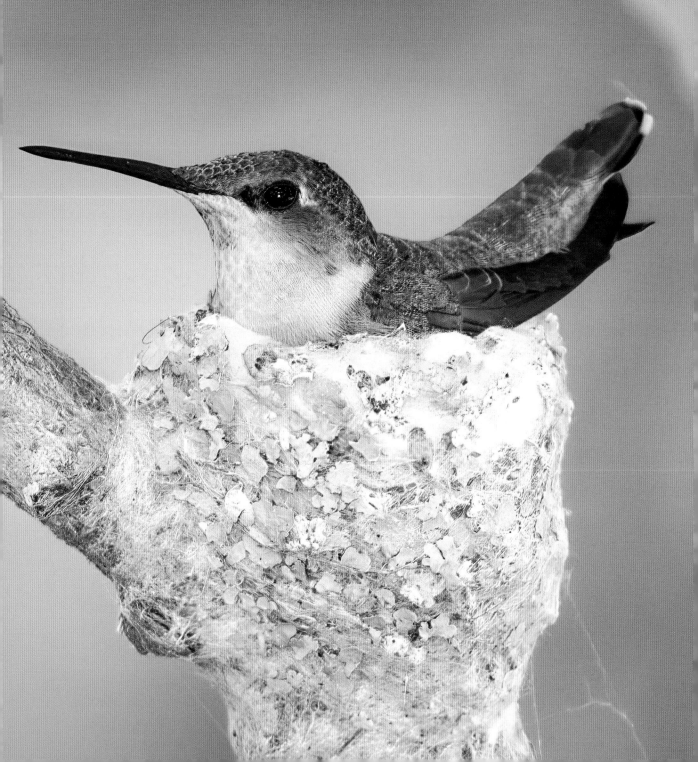

Ruby-throated Hummingbird

Flexible nest

A hummingbird nest is unique. Not only is it exceptionally tiny and camouflaged, it's also flexible. When first built, it is only the size of half of a walnut shell—just large enough to accommodate the adult and a couple tiny eggs. After the eggs hatch, there's still plenty of room. Space reduces when the babies start growing, but the spider webs and soft plant materials allow the nest to expand as the chicks get bigger. By the time the young are ready to leave the nest (fledge), they are full-sized hummers.

Thus, a nest built for one adult female and two eggs eventually needs to house two birds of adult size. The nest expands slowly with the growing chicks, ultimately to nearly double the original size. Unlike the larger, rigid nests that other birds build for raising young, these stretchy nests are truly an engineering marvel. Without nest wall flexibility, raising baby hummers to full size in such a tiny nest would be impossible.

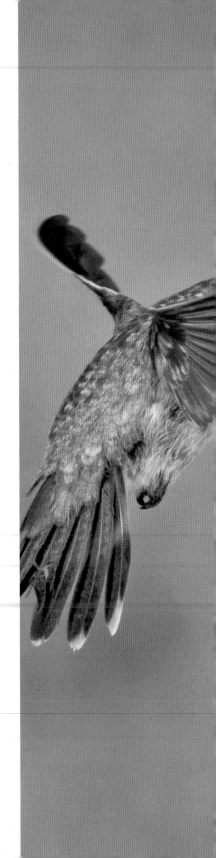

Mating encounters

When nest building nears completion, the female leaves her territory to look for a mate. Unlike many other bird species, hummers are solitary birds for most of their lives. At this time a female will solicit a vibrant male with a sparkling gorget for mating, but won't have any more to do with him after that.

Mating is a brief encounter after the female accepts the male. If she doesn't like him or isn't ready to mate, she will become actively hostile and chase him away. Copulation takes place on a branch or occasionally on the ground. The male will land on the back of the female and pass a sperm packet to her at the moment the base of their tails touch. Afterward, the female returns to her territory and nest while the male flies back to his territory. Mating occurs in the territory of the female, the male or sometimes on neutral grounds.

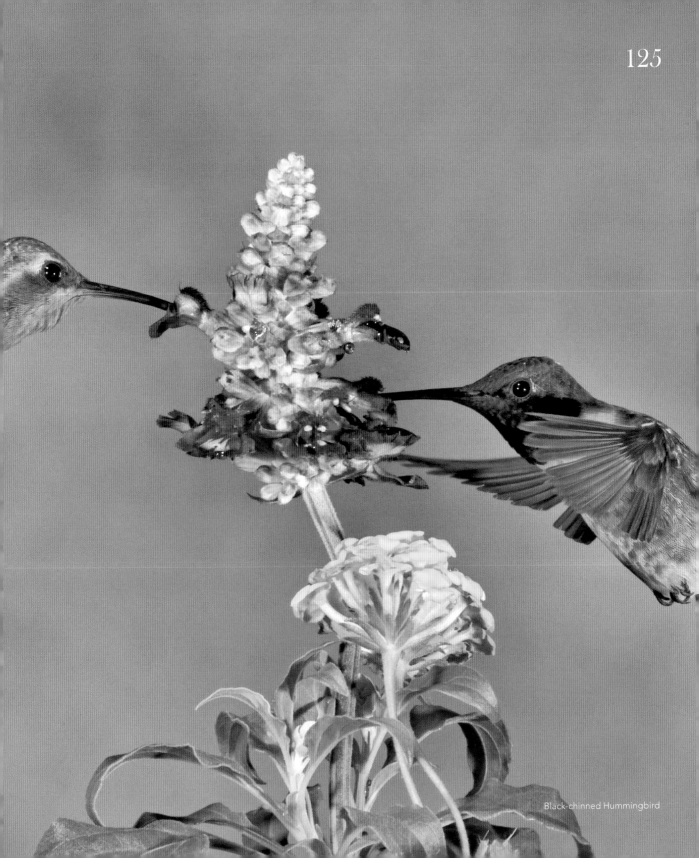

Black-chinned Hummingbird

Ruby-throated Hummingbird

Egg laying

Eggs are laid within days after mating. Females lay a maximum of 2 eggs, although rarely there are 3-4 eggs in one nest. Additional eggs result from egg dumping, which happens when a female deposits her eggs into a different nest. This is not well documented, but does occur.

An egg takes 24-30 hours to develop within the reproductive tract, but only several minutes to deposit. Once the egg is ready, the female sits tightly on the nest and promptly lays the egg. The second egg is laid in another 24-48 hours. The mother doesn't sit on the first egg during this time and often stays away from the nest. She will return to the nest when the next egg is ready and within minutes, she will lay the second egg. The female either remains on the nest and starts incubating the eggs immediately, or she'll leave and return the next day to begin the incubation process. The reason for waiting another 24 hours to start incubation is unclear, but in either case, she needs to start incubating the eggs at the same time to synchronize simultaneous hatching.

Dainty eggs

Hummingbird eggs are incredibly tiny, about the size of a pinto bean or half of a jelly bean. The eggshell is papery thin and fairly fragile, but this isn't problematic. The mother is so lightweight, there is no danger that she will crush the eggs during incubation.

chicken

hummingbird

ostrich

Ruby-throated Hummingbird

Incubation duty

The female is the sole incubator. She will spend 23 hours or more each day sitting on her eggs during the incubation period. She leaves the eggs only to stretch her wings, feed, drink and defecate. When she leaves, her eggs become vulnerable to avian, reptilian and mammalian predators. The decorative camouflage that she attached to the nest exterior is now crucial in reducing these dangers.

On average, hummer eggs take about 14 days to hatch. Ruby-throated Hummingbird eggs take 11–14 days to hatch, Black-chinned Hummingbird eggs take 13–16 days and Blue-throated Hummingbird eggs, which are the largest, take the longest, at 18 days.

Brood patch

During incubation, the temperature of the eggs is critical. Too hot and the eggs will cook. Too cold and they won't develop. All heat for incubation comes from the mother's body. To transfer her body heat to the eggs, direct contact between her skin and the eggs is necessary. For incubative purposes, a female hummer plucks the downy feathers from her belly, leaving a bare spot of skin called a brood patch. She covers the delicate patch with her contoured body feathers when she's away from the nest and moves them aside at her return to warm the eggs.

The body core temperature of female hummers runs around 105-109 °F. Egg temperature needs to be about 95-97 °F. Since the mother fits so tightly in the nest, air does not circulate underneath her and heat is trapped. Depending on outside ambient temperatures, the mother raises herself up or lowers herself down on the eggs to control the incubation temperature. Her position is so precise that egg temperatures can be estimated by observing the position of the mother on the nest.

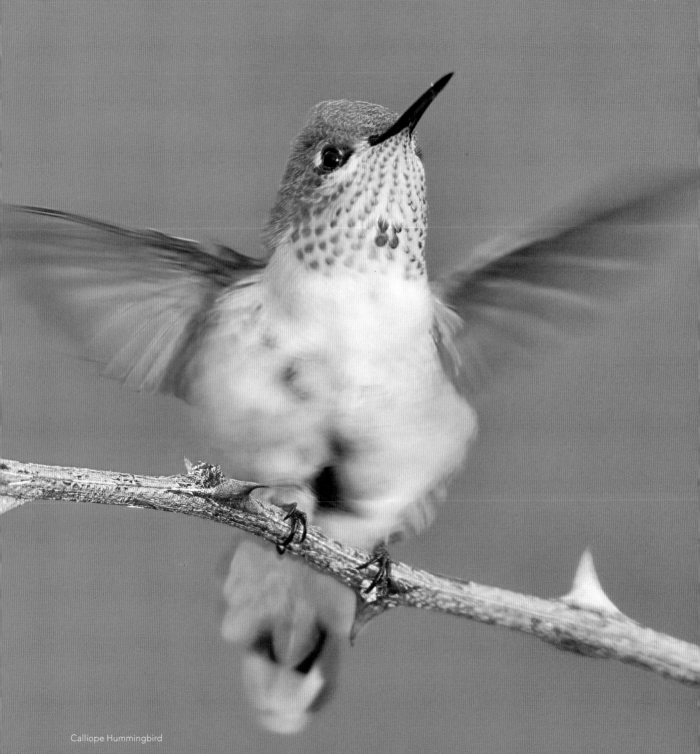

Calliope Hummingbird

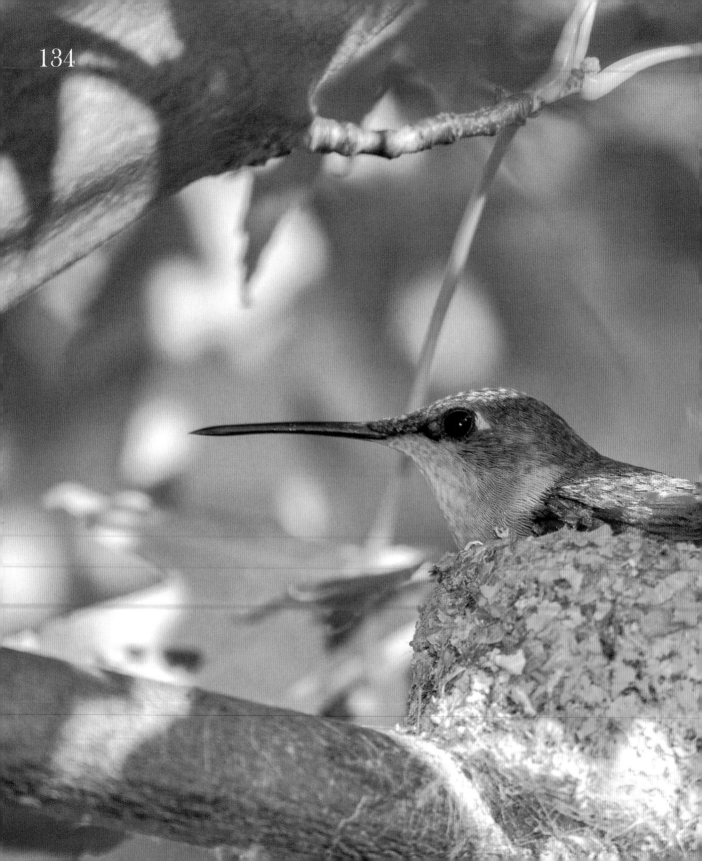

Hatching

Hatching is a slow and laborious process. To pierce the first tiny hole in the eggshell, a baby hummer slowly rubs the tip of its bill against the inside. The action of making a tiny hole is called pipping. After pipping, the ever-so-tiny bird spins around while rubbing a line into the shell that, with pressure, will eventually split the egg into almost equal halves. This can take up to 24 hours or more. Meanwhile, the mother typically sits on the eggs and doesn't offer much help. Once the eggshells split and the chicks are released, the mother carries away the broken shells to make room for the new hatchlings to grow.

Ruby-throated Hummingbird

Feeding the young

To feed her young, the mother needs to gather nectar. She will make hundreds to thousands of trips between a feeder or favorite flower patch and the nest. When the female returns with food, she perches on the nest edge. The nestlings feel the vibration of her landing and automatically raise their heads and open their beaks. The mother inserts her bill and regurgitates the nectar into their throats, which makes feeding time for the youngsters a bit like sword swallowing. This activity continues until the young have grown and are ready to leave the nest.

Later, after the young hummers leave the nest (fledge), the mother will continue to provide nectar for a few days. Youngsters perch on a branch in wait of food, fluttering their wings and opening their bills whenever their mother flies near. She may land next to them or carefully hover in front to deliver their sweet meal. Soon, however, the young will need to find all of their food on their own.

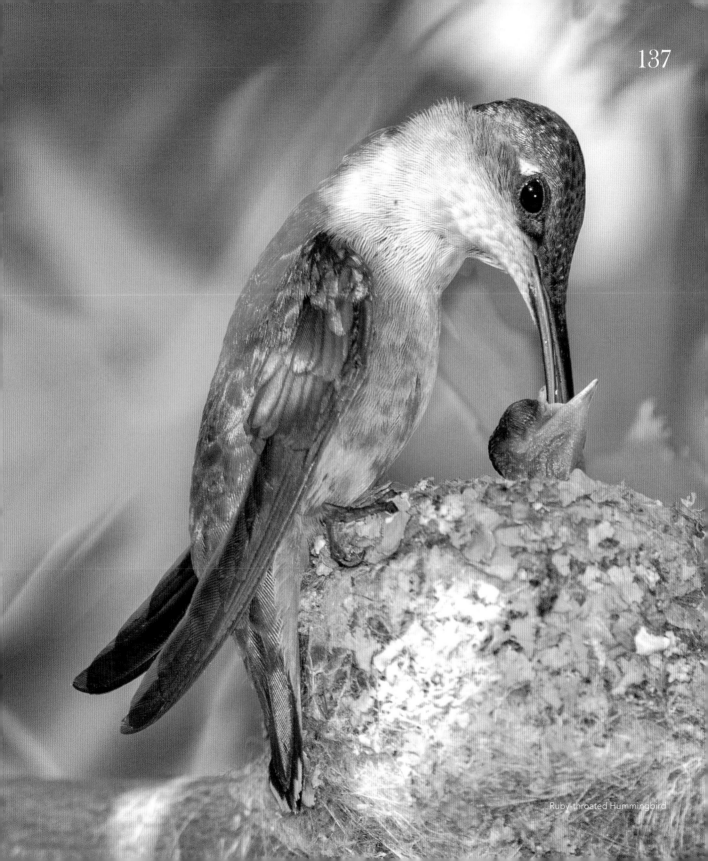

Ruby-throated Hummingbird

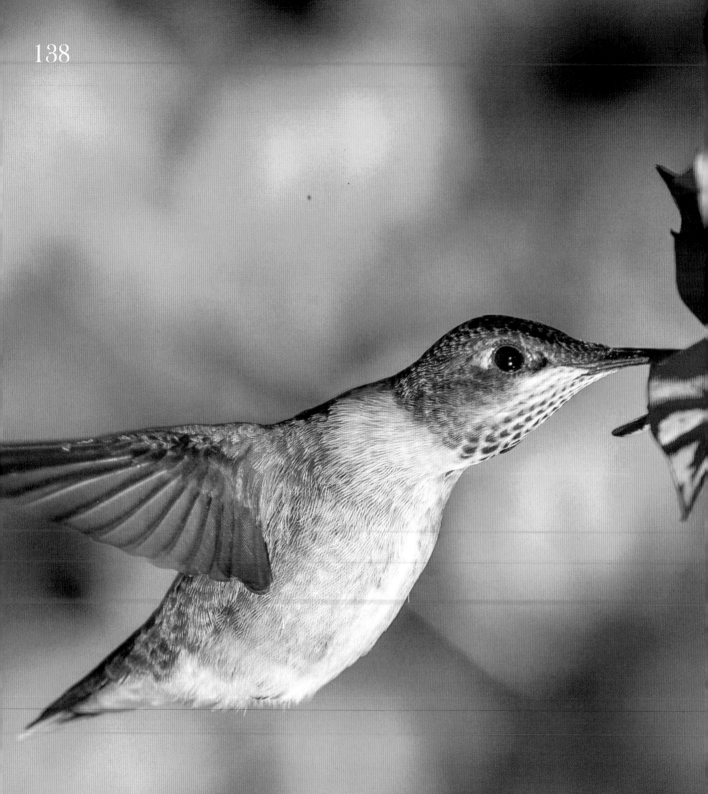

juvenile Ruby-throated Hummingbird

Fledgling life

After leaving the nest, or fledging, young hummers remain with their mother for only a short time. Soon they will be responsible for meeting their own nutritional requirements. By the end of the summer, mothers and young are visiting nectar feeders and flowers together, although sometimes with aggression and hostility toward each other. This is a time of even more competition among hummers, when both young and adult females chase adult males away from the feeders.

At summer's end, only female adults and juveniles are left visiting feeders. The adult males have already flown off for migration, and adult females are the next to leave. Several days to a week after the mothers are gone, the juveniles head out. Because each hummer migrates by itself, how the youngsters know where to go and how to survive during migration remains an intriguing mystery.

Independence

At just a month or two of age, young hummingbirds are mostly on their own. By the end of their first summer, they are totally independent and will make their first migration by themselves.

Hummingbirds returning in their first year are ready to breed. They often come back to the place where they hatched, which is their mother's domain. When the mother is already at her breeding grounds, she will drive them off, forcing them to find their own territory. If not, they will claim it as their own.

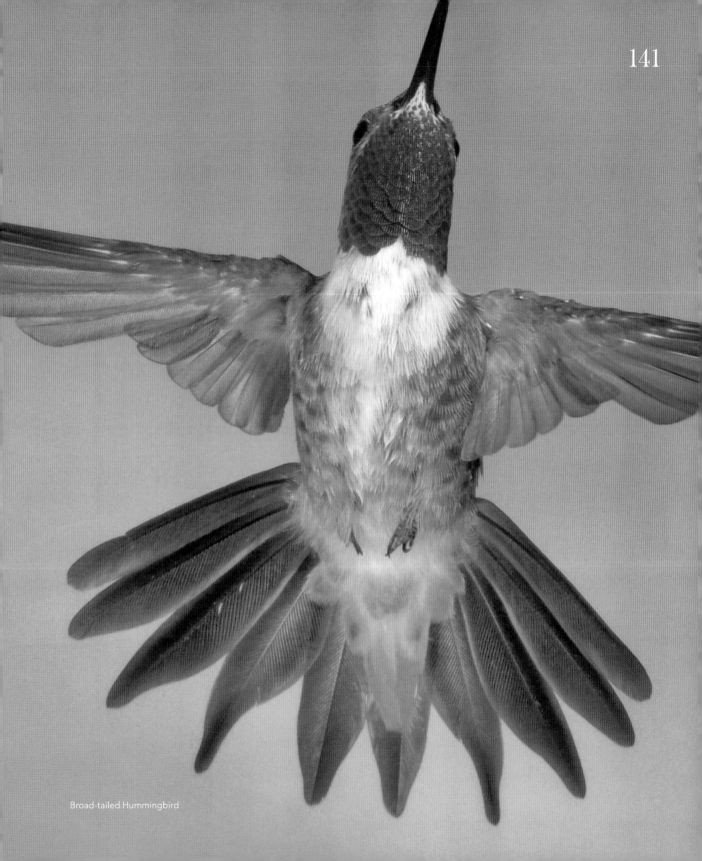

Broad-tailed Hummingbird

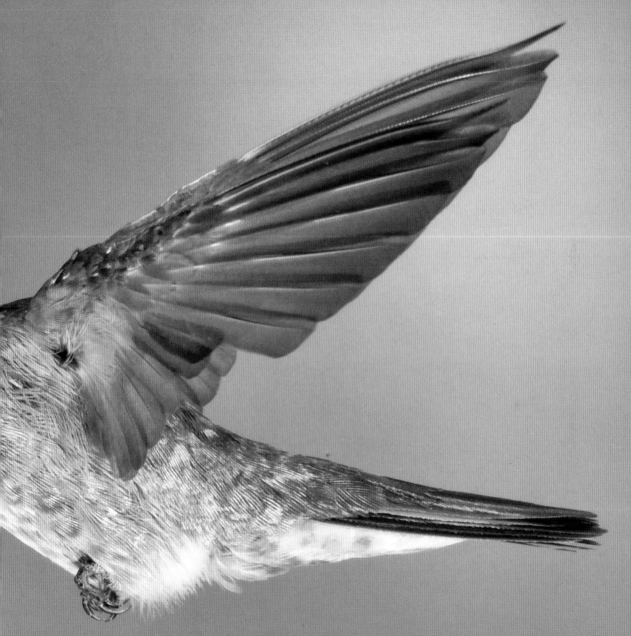

Broad-tailed Hummingbird

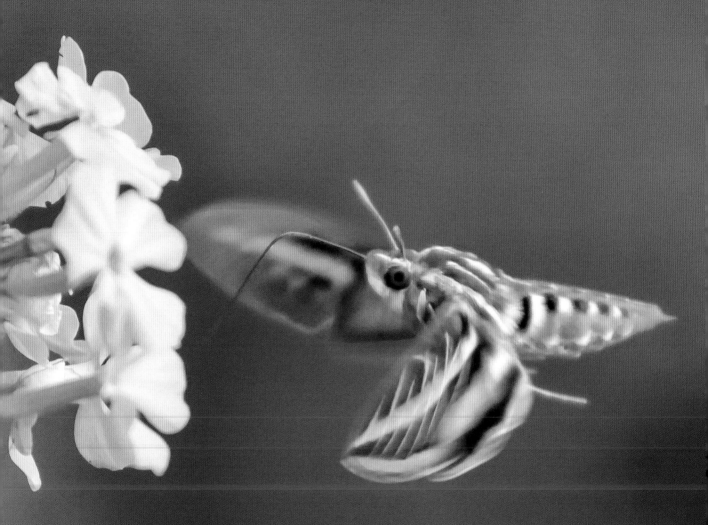

White-lined Sphinx

Hummingbird moths

As summer draws to a close, gardeners may see what appears to be a graceful hummingbird silently visiting flowers late in the evening. This quiet visitor, which does not make a humming noise, would be a newly emerged hummingbird moth or sphinx moth. Sphinx moths are large daytime moths that have a long straw-like mouth part, called a proboscis, that coils up when not in use and uncoils for sipping nectar. A sphinx moth flies to a flower and hovers in front, just like a hummingbird, but it will unroll the proboscis and thread it into the flower to sip nectar. It is an interesting insect to watch and another wonderful visitor to your garden.

Attracting hummers

Depending on your location, it can be fairly easy to attract at least one hummingbird species to your yard. First, you will need some red flowers or other colorful blossoms to flag down the hummers as they whiz past your home. A big flowerpot with red annuals will do the trick. To be ready for the first arrivals, buy some greenhouse plants early in spring and plant them in the pot. Next, pick up an inexpensive shepherd's crook pole, stick it in the middle of the flowerpot and hang a nectar feeder from the hook. Place this arrangement on your deck, patio or near your garden as a warm welcome, and soon the birds will be stopping in to feed. After you are successful in attracting your first hummingbirds, you can expand your nectar feeder offerings.

For the more ambitious, a perennial garden filled with a hummingbird's favorite native and cultivated flowers is the way to go. You'll be surprised how quickly your new garden will take root and take shape. Check with your local nursery or go online to learn which kinds of flowers will grow in your region and attract hummers.

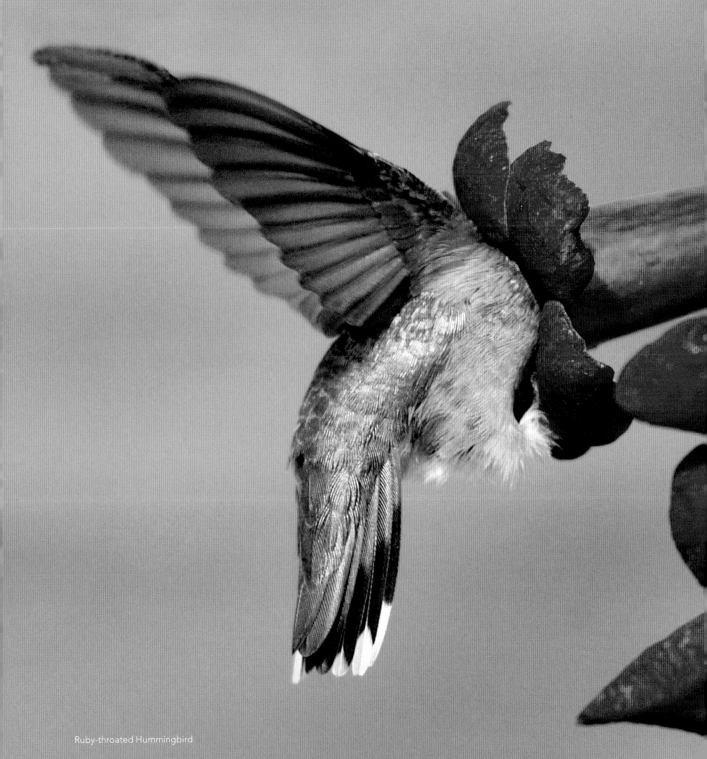

Ruby-throated Hummingbird

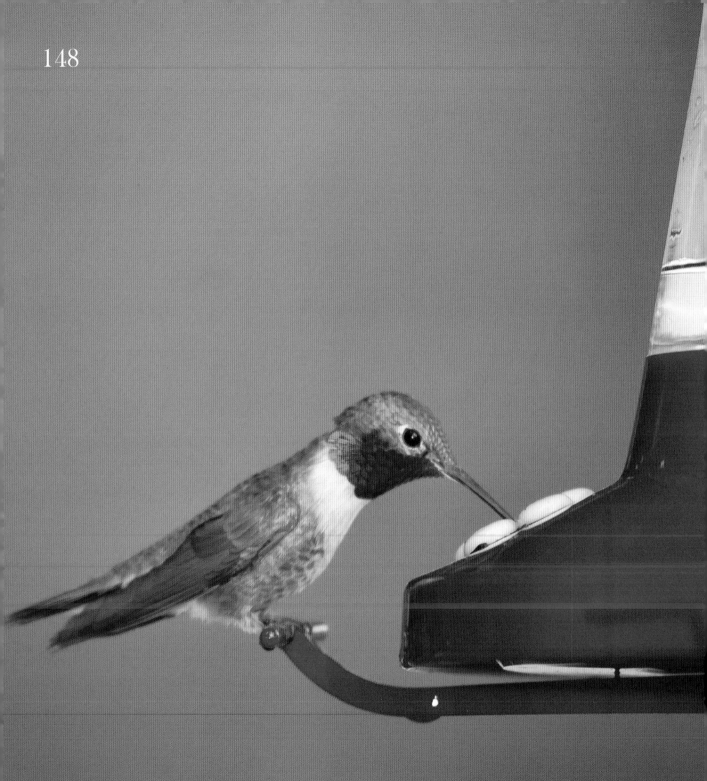

Broad-tailed Hummingbird

Choosing feeders

Once your garden is planted, put up a couple hummingbird feeders. To fully enjoy your dashing visitors, place a nectar feeder where you can see it from the interior of your home. You will have more success inviting hummers when the feeder is in shade or near several places where birds can perch. Don't be afraid to put feeders near your home, under eaves or suctioned to windows. Hummers have no trouble coming close to houses. The more feeders you provide, the more hummers you will attract.

Place multiple feeders at least 25 feet apart. If a hummer is successfully defending a feeder and keeping all other hummingbirds away, place the second feeder where the first bird can't see it. This will allow the other hummers to feed without being harassed.

Not all hummingbird feeders are the same. Choose feeders with plenty of red color. Don't put any dye or food coloring into your nectar solution to make it red. Red dye is not natural and may not be healthy for hummingbirds. Instead, rely on the feeder color itself to draw the birds.

Bee guards are important. These are tiny plastic devices that fit over the feeding holes and discourage bees and wasps from visiting. Ant guards are also beneficial. These simple cups (motes) with hooks on the top and bottom are fantastic at keeping ants away. Some feeders have built-in ant motes. Fill the mote with water and top it with a thin coat of vegetable oil to retard evaporation.

Feeder containers come in glass or plastic. If you have a problem with raccoons, consider plastic to avoid a mess in case of an accident. When pests are not a nuisance, you might prefer glass. Nectar solution in glass stays clean longer, and glass washes more easily than plastic without marring.

Nectar recipes

Most nectar in flowers is about 25 percent sucrose. To replicate flower nectar, mix a simple solution of 4 parts water to 1 part granulated white sugar. Do not use artificial sweeteners, honey, flavorings or add food coloring. To help prevent mold from developing in the solution, boil the water for two minutes, add the sugar and let it cool before filling the feeders. This is an important step, especially during hot weather. Store any unused nectar in the refrigerator or freezer.

If the birds are drinking most of the nectar each day, you can mix up fresh nectar using warm tap water and sugar and skip the boiling. This nectar can't be stored for any length of time, but it works when feeders are being drained daily.

When the solution in a feeder gets low or starts to appear cloudy, bring the feeder in for a soapy wash, thorough rinse and fresh refill. Well-fed hummers that are healthy and happy are sure to keep delighting you as they come back to your feeders for more.

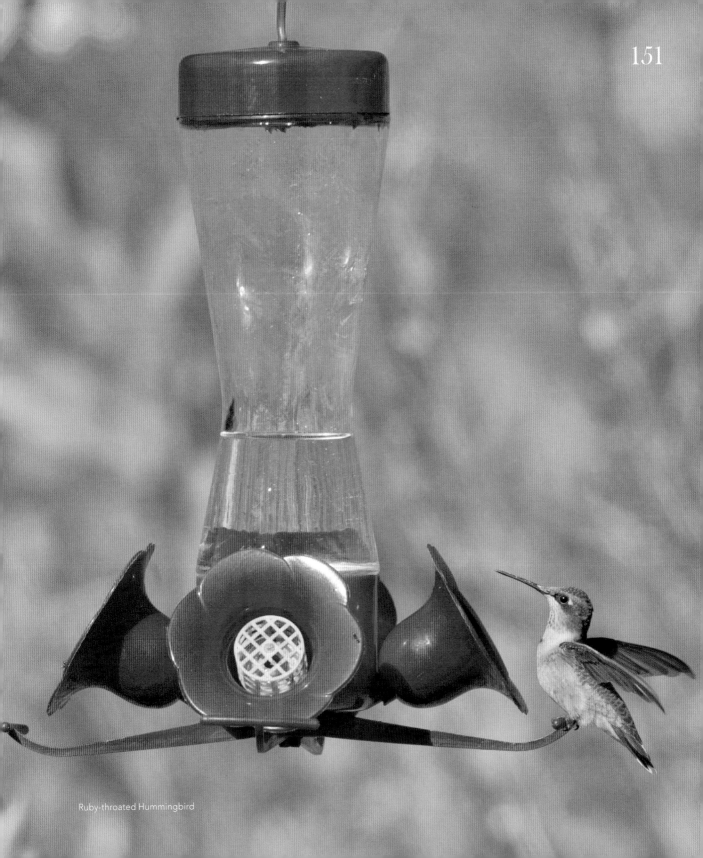

Ruby-throated Hummingbird

Hummer myths

These common notions about hummingbirds continue to persist despite the fact that they are false:

- Hummers feed only at red flowers.

- They consume nothing else but nectar.

- They will drink homemade nectar solution only if red food coloring is added.

- Hummingbirds suck up nectar, using their bills like a straw.

- A nectar feeder left out too long after summer ends keeps resident hummers from migrating.

- Hummingbirds migrate on the backs of geese.

- They are constantly in flight and never land.

- They can't walk.

Rufous Hummingbird

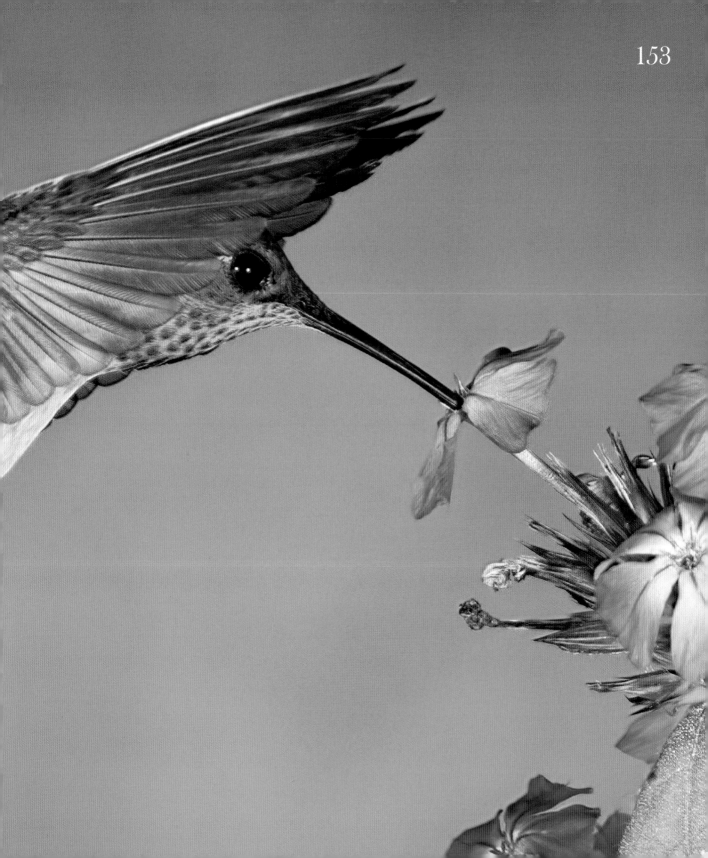

Tiny flying jewels

Hummingbirds are engaging birds, so beautiful and full of energy. When these high-spirited fliers visit our yards to feed, they spill joy into our lives. I can't imagine a world without these tiny flying jewels, nor could I go a season without having them buzz around my feeders. I make extra efforts to see, feed and photograph these lively birds and they never disappoint. I have no doubt that I will always have a special place deep in my heart for our amazing hummingbirds.

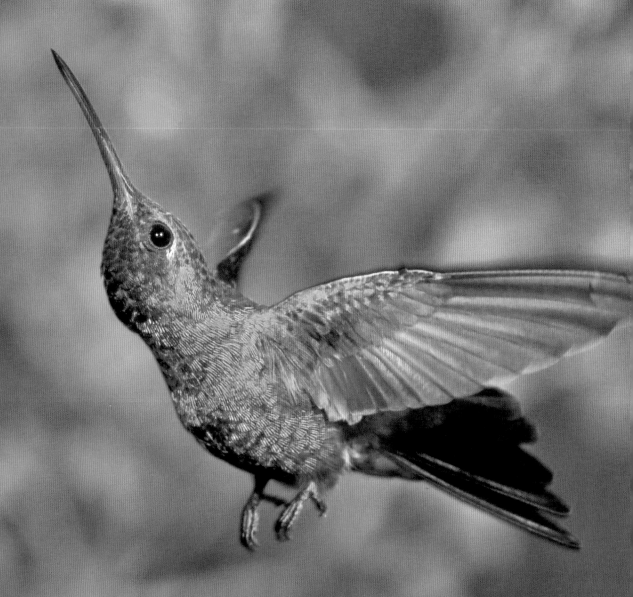

Broad-billed Hummingbird

Featured hummingbirds

This photo spread shows all 16 species of hummingbirds in the United States and Canada and their ranges. Ranges shown in red indicate where you would most likely see hummers during the breeding season. Ranges for migration are shown in orange. Like other birds, hummingbirds move around freely and can be seen at different times of the year both inside and outside their ranges. Maps do not indicate the number of hummers in a given area (density).

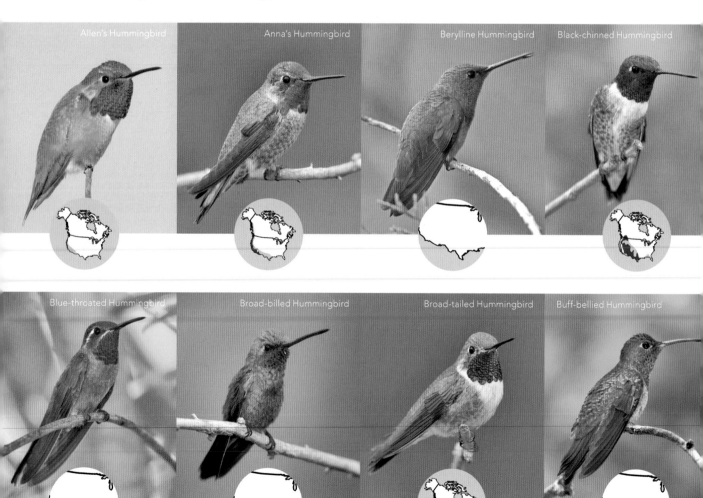

Allen's Hummingbird

Anna's Hummingbird

Berylline Hummingbird

Black-chinned Hummingbird

Blue-throated Hummingbird

Broad-billed Hummingbird

Broad-tailed Hummingbird

Buff-bellied Hummingbird

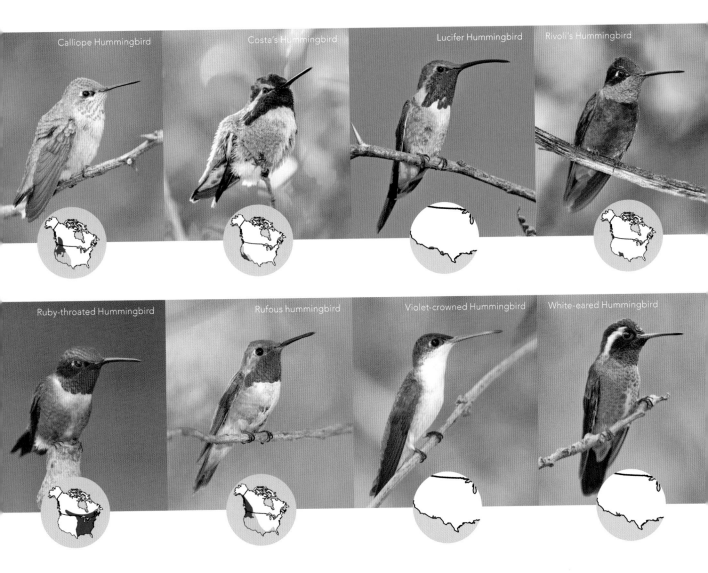

Calliope Hummingbird

Costa's Hummingbird

Lucifer Hummingbird

Rivoli's Hummingbird

Ruby-throated Hummingbird

Rufous hummingbird

Violet-crowned Hummingbird

White-eared Hummingbird

How to attract humming-birds to your yard

When you spot a hummingbird in your yard or garden, it's always a delight. If you take some easy, cost-effective steps, you can make your yard more welcoming to hummingbirds and birds and wildlife generally. Here are some simple tips to get started.

Put up a hummingbird feeder, but don't use red dye

You can also welcome hummingbirds to your yard by putting up a sugar-water hummingbird feeder. These often-red bottles hold sugar-water, which easy to make yourself (mix four parts water and one part sugar), which hummingbirds will visit often, once they discover the feeder. Be sure to buy a feeder with bee/wasp-proof nozzles, as they're attracted to the sugary stuff too. Wash out your feeders at least once a week.

Don't spray pesticides or herbicides in your yard

Hummingbirds eat a whole lot more than plant nectar. In fact, like many birds, they depend a great deal on insects and arthropods for food, and even for nesting materials. Unfortunately, many of the insecticides that homeowners commonly use in their yards are broad-spectrum, which means they don't just target one insect species. Mosquito foggers are an example: they kill far more than just mosquitoes, including bees, butterflies, and other insects and arthropods. (This includes spiders; spider silk is often a component of some hummingbird nests.) Pesticides and herbicides also harm birds directly as well, so if you can avoid using them, you'll make your yard more bird-friendly.

Native plant options for hummingbirds

Hummingbirds are well-adapted to the native plants in their geographic range. Generally speaking, these plants have similar characteristics (bright colors, tubular flowers), but the particular plants vary by region. Here are some suggestions for hummingbird-friendly plants for the major regions in the U.S.

Northeast

Common Milkweed
Denze Blazing Star
Trumpet Honeysuckle
Blue Wild Indigo
Common Buttonbush
Cardinal Flower
Foxglove Beardtongue
Great Blue Lobelia

Midwest

Anise Hyssop
Marsh Blazing Star
Trumpet Honeysuckle
Trumpet Creeper
Red Columbine
Foxglove Penstemon
Cardinal Flower

Southwest

Autumn Sage
Desert Honeysuckle
Hummingbird Trumpet
Pineapple Sage
Red Yucca
Cardinal Flower
Parry's Penstemon
Scarlet Betony
Wild Bergamot

Southeast/South

Black-eyed Susan
Indian Blanket
Lanceleaf Coreopsis
American Beautyberry
Florida Dogwood
Compass Plant

Northwest

Columbine
Honeysuckle
Indian Paintbrush
Canada Goldenrod
Checkermallow
Penstemon (all)

Cardinal Flower

About the author

Naturalist, wildlife photographer and writer Stan Tekiela is the originator of the popular Wildlife Appreciation series that includes *Cranes, Herons & Egrets*. Stan has authored more than 190 educational books, including field guides, quick guides, nature books, children's books and more, presenting many species of animals and plants.

With a Bachelor of Science degree in natural history from the University of Minnesota and as an active professional naturalist for more than 30 years, Stan studies and photographs wildlife throughout the United States and Canada. He has received national and regional awards for his books and photographs and is also a well-known columnist and radio personality. His syndicated column appears in more than 25 newspapers, and his wildlife programs are broadcast on a number of Midwest radio stations. You can follow Stan on Facebook, Instagram and Twitter, or contact him via his website, naturesmart.com.